Also by Anna Levin

Ripples on the River:
Celebrating the Return of the Otter

My Friends Who Don't Have Dogs

Incandescent: We Need to Talk About Light

The Magic Moment: Extraordinary
Photographs of Nature

Was it a Whale? A Handy Guide to the
Marine Mammals of the Hebrides

IN THE MOMENT

Dark Skies

Anna Levin

Saraband ◉

Published by Saraband
3 Clairmont Gardens
Glasgow, G3 7LW
www.saraband.net

ISBN: 9781916812222
eISBN: 9781916812239

Printed and bound in Great Britain by Clays Ltd,
Elcograf S.p.A.

1 2 3 4 5 6 7 8 9 10

MIX
Paper | Supporting
responsible forestry
FSC® C018072

*For my dad, Michael Levin, with thanks
for all the support and encouragement
through this book and always.*

Contents

Contents

Craving Darkness

I am craving darkness. I'm craving it physically like a vital nutrient. It's a sustained longing that's as distracting as toothache, urgent as thirst. It's specific: I need a particular type of darkness and my craving cannot be fulfilled with an eye mask or blackout blinds on the windows, nor by switching the light off in a windowless room. No, the darkness I seek is alive – wind ripples through it, trees breathe within it and owls call into it. It is not absolute: it shifts as clouds drift, shapes reveal themselves inside it given time, stars peer through it and sometimes the moon casts silver all over it.

This darkness is not about absence but presence – it has energy and, above all, a texture that's both sharp and soothing, exhilarating and calming. I feel a tension that will not release me until I can be enveloped in real, vibrant darkness. I want to breathe it in, then relief will come, rich and soothing and sustaining.

But where can I find darkness? Like most of humanity now, I live in a city and where there are people there is light always. It's a gently-lit place as cities go, but still, lights from an industrial estate and new houses shatter the peace of the riverside

commons near my home. I plan my holidays as a pilgrimage to darkness. A cottage on the edge of a small Scottish village sounds promising, with no roads or houses behind, just open fields and woodland. My hopes rise as dusk falls and I sit with a cuppa on the back doorstep. Colours fade, bats flicker... and then a row of artificial Christmas trees in a neighbouring garden erupts into life with flashing blue lights. They stay on all night long. It's August.

I try a campsite in the woods, hoping to look up through trees decorated with stars and to fall asleep to the sounds of the forest at night. Again, dusk is accompanied by an abrupt rush of light – all along the pathways, a dazzle around the toilet block and rows of motorhomes bedecked with strips of lights in a particularly ugly grey-blue hue.

This is wild camping so I am beside the shore, with grassy slopes behind me and only the darkening ocean ahead of me, dotted with a few distant lights from fishing boats. I savour the colours of the fading sun glowing in the sea and sky. Then, on the brink of a hill to the east, an astonishingly bright light appears and dominates the dusk so that it draws my eye but I wince each time I glance in that direction. There's only one building up there. It's a golf course clubhouse. It's shut, of course.

It turns out I'm not alone in my flinching or my craving. I'm both relieved and deeply troubled to learn how many others are also struggling with the sheer amount of artificial light at night, and the intensity of it. Some of those others are my fellow humans. Many more are different species.

I learn this from my work as a journalist on the interface between science and the general public: that the current level of brightness at night is something new to life on Earth. It is affecting and threatening every aspect of the living world. From insects to deep-sea fish to trees. Everything. From the organs within any individual to the wellbeing of a whole population. Everything. From single-celled organisms to ecosystems and all the complex inter-actions between species and their habitats. The whole web of life that constitutes the living world is craving darkness, too.

In the natural world, the rhythm of light and dark is time itself, and always has been. Life on Earth evolved to the steady ticking of a great celestial clock-work. The evolution of the living world has been governed by our small planet's relationship with one star that it circles, and the reflections of light from that star on a rock that circles us. The perpetual motion of these orbits gives us day and night, the waxing and waning moon and the changing pattern of light and dark at different latitudes through the seasons.

Over time life emerged and developed to fit not just the niche of habitat – whether ocean, rainforest or tundra – but also the niche of a particular pattern of light and darkness. The balance of day and night through the seasons has been the constant on an ever-changing planet. Life has had a lot to cope with on its journey through the millennia from single-celled blobs in the sea to finding legs on land and wings in the skies. Tectonic plates have shifted and clashed, continents have collided together and torn asunder, volcanoes have erupted, comets have struck and ice ages have come and gone. Geography hasn't been stable; time has been the rock with the steady beat of light and dark. And to that rhythm life developed and diverged into all the incredible forms that we know today.

That celestial clockwork keeps ticking all day and throughout the night, subtly shifting the levels of light so that life always knows what time it is. From the blush of dawn to the clear, bright light of morning it builds in a crescendo to midday, then softens again and warms before it fades. Night comes in incremental stages, with dusk deepening into rich blackness and then the darkness easing and ceding to dawn. Into this dynamic darkness come the changing natural nights of the light, through the days, months and seasons: the phases of the moon, the positions of the stars and planets, the bright streak of the Milky Way.

So in millions of years of evolution, life has not experienced a change like the loss of darkness over the past one hundred years. In this last decade alone there has been an exponential rise in the quantity of artificial light and significant changes in the quality of it, due to new lighting technologies. The amount is growing still, and is no longer limited to places of dense human population. Sky glow bounces light back many miles from the cities and the sudden steep rise in numbers of satellites is making the sky brighter all over the Earth. Though light pollution is complex and difficult to measure, the increase is currently estimated to be growing by 400% in some areas. It's a dizzying rate of destruction. It's taken us a long while to think of light as pollutant, but now we know that light pollution is another man-made scourge that's spreading across the whole planet. If we continue on this trajectory we will lose not just the darkness but our view of the heavens. Very suddenly in evolutionary terms, darkness is being vanquished from much of the world and night is an endangered, disappearing habitat.

Given the complexity of life's responses to darkness and light, what are the consequences of these changes? In terms of the living world we have wrecked time: we have broken the clock, ripped up the calendar and lost the schedule. Current developments in circadian science are revealing

how nearly every system of the body is 'circadian entrained' – governed by the body clock. So when the body clock is out of kilter everything else goes awry, including the immune system, blood sugar, digestion and cell renewal, with implications for cancer, diabetes and many other major diseases. As it is within the body, so it is within the planet: when the circadian basis for the living world's interactions is disturbed, it affects every living system within it.

Like the rest of life on Earth, humans have evolved to a rhythm of day and night. It's how our minds and bodies work, under the control system – far more than we realise – of the body clock. This rhythm has been normal for almost all of human history and is an intrinsic part of human experience. Our society evolved and developed within this. Then, very suddenly in the human story, we came up with this idea of a 24-hour economy. We're the first human generation to expect shops and petrol stations to be open all hours and for transport to run through the night. We've got so used to it so quickly that in many towns and cities it's the twenty-first century normal. What did people do before they had a corner shop open until 10pm or a 24-hour supermarket down the road? Or before they could work through the night syncing with different time zones across the world?

Maybe we relaxed, rested, and slept. Our eyes experienced dimmer lighting levels and transmitted that information via the retina to the rest of the brain. The message triggered hormone changes that eased the body towards sleep. And while mind, body and soul rested, other systems kicked into gear. Many physiological processes take place during the downtime of body and mind – renewing, repairing, healing and regulating… vital things that we're oblivious to until they go wrong. They work better in darkness: lose the dark and they will go wrong.

Something else is going wrong too. The craving is deeper still. I'm not just craving darkness, I'm craving a real, natural, actual night. I'm longing for a regular experience of the sky at night. I want it every night. I want the texture of thick, black darkness when the clouds are muscling up ahead, and the exultant expanse of a vast array of stars when the skies are clear.

Because darkness was 'normal' for almost all of human history, it had importance and significance – as did dawn, dusk, the moon and stars and any celestial activity. The weather at night had significance, because the difference between a moon or star-filled night or a cloudy night was immense. The night sky was part of our language, songs, stories, beliefs and daily activities. We also read deeper meaning into the changes of the night sky. We looked to it for guidance and signs of the future.

Does any of that matter now? Do we need the night sky anymore? Now that we no longer use the stars for navigation or the moon for an agricultural timetable, and we don't think an eclipse will foretell the death of a king, is the night sky any more than a nerdy fascination for astronomers? Is it more significant than a vague aesthetic interest for the rest of us? A new generation growing up in cities around the world have barely ever seen the stars. Why would they care? Will they even miss what they've never known?

We need the stars and the night sky more than ever before. These things are part of our experience of being human and our sense of ourselves – it's not something we can be without. As our bodies and minds need to experience darkness to thrive, I think our souls need the natural lights of the night to flourish. There is something about the immensity of a starry night sky that evokes awe: that humbling, yet exultant sensation of being tiny and yet huge, insignificant and yet powerful, intrinsically connected to something so big. Engaging with light from two million years ago or a few billion miles away somehow alters time and space. It puts people in their place. Now psychologists talk of an 'awe-deficit' among people in an insular, digital age when everything is supposed to be connected but we are profoundly disconnected. The loss of 'wow',

of a deep sense of humility and relationship, can result in a distorted ego, an over-inflated sense of self and a ghastly vacuum where a connection with others and the beauty of the world should be.

Faced with artificial light's global assault on darkness, what can we do? First and foremost, we need to notice what's being lost and the damage that's being done. Think for a moment of the most beautiful view you have ever seen, the one that makes you gasp out loud. Now imagine an obstruction is being built – a lumping great building or a huge, ugly monument – right in front of it. It obscures your view entirely or leaves only a glimpse that you have to travel further and further to see. What would you do? Would you be outraged? Would you complain and protest? Would you team up with others to tear it down?

There is a view that is one of the most beautiful on Earth and has been eliciting gasps since the beginning of time. We have gazed at it for millennia, woven our stories and dreams around it. It's the birth right of every person and every other creature in our world. It is the view of the natural night sky full of stars. And we are building the obstruction in the form of a thick veil of light pollution, fast covering the sky. It's a monument to our warped values, unfounded fears and astonishing capacity to waste energy. How can we tear it down? There's a

lengthy battle plan ahead, involving local measures and international cooperation and legislation, all for a relatively simple concept: turn off the lights.

The first step is awareness. We need to remember what's behind the veil and show that to others who may have forgotten. We need to experience darkness and the starry skies to become re-enchanted with the night. Humanity needs to re-discover and remember what it has always known – that the night sky is significant and essential to us. We need a fix, now more than ever, of that enormous expanse of trans-formational beauty that stretches us and somehow connects us, to immensity, to ourselves, and to each

Joining the Dots

I must have been about thirteen years old, on a Girl Guide camp in a field in northern Lancashire. I wasn't really Girl Guide material; wearing a uniform was a penance that had to be endured at school and not something I'd choose in my free time. So I never joined properly, but somehow they let me come along anyway for what I saw as the 'good bits' – campfires on the shore, melting chocolate into bananas slit lengthways, and, best of all, sleeping under the stars.

So there we were in a huge field, free within the limestone wall that curved along its boundary. It was the first time I ever remember lying down to look up at the night sky. Sure, I'd seen the stars before; we'd moved here when I was eleven, from the city to this coastal village. I was aware of the darkness at night and the sheer quantity of stars. But this was different. We had all the time and space, nothing to do but gaze, and the perfect angle from which to do so.

Crane your neck and look up into a star-clustered sky, and I guess you take in about 90 degrees of the view, a bit more if you tip your head right back. Lie down and that angle widens expansively – suddenly the sky gets a whole lot bigger. Somehow it feels like

360 degrees of sky. That's what I remember – the sense that the stars were above, around and beneath me. I was vaguely aware of the caterpillar-people in sleeping bags snoozing and shuffling or gently chatting close by. We lay on our camping mats in a wide circle near the middle of the field, our toes towards each other, the heavens above us all. As the sky edged from deepest blue into indigo and then on towards black, more and more stars appeared. They were scattered and strewn above me, or was it below me? I stared and stared and stared until I was in space, floating through this immensity on a small, round, turning planet. The edgy feeling that I might fall off the world and into the darkness just added to the thrill of that night.

Gradually the chattering around me ceased, ceding to gentle snores and the heavier breath of slumber, then silence. Was everyone else asleep? The girl closest to me was. The light of the night was glancing her skin with just a silvery hint of contours: chin, forearm and upturned hand. I'd never felt more awake or alive myself, snug in my sleeping bag cocoon with the whole universe twinkling and shining above and all around me. I wanted never to sleep, just to drink it all in: the cool night air and the smell of the grass and the million, billion, gazillion stars.

Did they *all* have names, I wondered? I knew a few of the constellations, like Orion the hunter with

his belt and his sword, but where was he? I couldn't see him, but I spotted the saucepan and wondered why it was called the Great Bear. Then there was the 'W' – was that called Cassiopeia, and why? What does a bear have to do with a saucepan, or Cassiopeia with a w? I had vaguely remembered notions about them and their stories and wondered if you could do a Girl Guide badge in stargazing. If you didn't wear the uniform, could you still get the badges? Where would you put them? Maybe you could just join the dots yourself, create your own stories. Trace the shapes across the sky and let patterns and pictures be revealed there, like you do when you're gazing at clouds. Maybe the names didn't matter? I was just there in the midst of it all, dazzled by the sky and the immensity. I felt tiny and enormous all at once. The bigness was glorious, my head dizzy with delight at such expansiveness, and my heart thrumming with a surge of optimism and hope.

I guess I must have fallen asleep eventually, but not before the images and sensations of the night were sealed into my mindscape. It was the first of such memories, and if I scan the path of my life now, dark sky moments and the natural lights of night shine along the way.

There's an evening in New Zealand when I was in my twenties, wallowing in hot pools after a day's fruit-picking in a mandarin orchard. The

thick sulphurous smell of the water quickly faded and I was aware only of the warmth and strange texture, the way my limbs softened and floated in it. Natural hot water was an unexpected delight of my New Zealand travels. It bubbles up through the North Island, in rivers, waterfalls and even beaches – there's a place you can dig yourself a bath in the sand. In some places the water is corralled into built-up pools with lights and changing rooms, else-where it just flows through the countryside. This was somewhere in between, basic wooden tubs with planks to sit on.

I leant back on the rough wooden edge, enjoying the curious sensation as steam swirled around me from the water below and cool air reached down from the darkening sky above. It made me think of pancakes with hot blackberry sauce and ice cream, the surprise in your mouth at the mix of tempera-tures. I shut my eyes, savouring it all, and when I opened them the sky was thick with stars, absolutely crowded with millions of tiny lights sprinkled in unfamiliar patterns. How could it hold so many? Were there more stars in the southern skies, or was the night here clearer than anywhere else I'd known?

I was missing my boyfriend, far away in Ireland, and somehow the sky made me vividly aware that he was on the other side of the world. He'd written to me, in blue airmail letters that waited at post offices,

that he found it strangely reassuring to know we would see the same moon. I'd glance up at the moon over New Zealand and think of it heading over to Ireland when day here turned to night there.

Later in life I'd settled in Scotland, first in Edinburgh and then a few years on the Hebridean island of Mull. I remember winter nights climbing up the steep streets and looking down on Tobermory Bay with the masts of the yachts gleaming in the moonlight, and the array of bright stars above. There must have been a lot of darkness on long winters nights, yet when I think of Mull my memories are of an abundance of light. Those summer evenings that stretched on and on when colours soften but barely fade. There's a texture to Hebridean twilight that I wish I could grasp and hold on to. Once I sailed from Mull to the Isle of Coll on a research boat kitted out for whale and dolphin studies. We anchored off the Cairns of Coll – tiny islands scattered by the north tip as if the main island crumbled into the sea. We stayed up 'all night', though there was no night, just a sequence of washes of richer then softer light. A big red sun gently lowered itself towards the sea as if considering a dip, then seemed to change its mind and hastened back up again into the dreamy sky. It was light all night, but it was real light, the right light, for the time and season on the turning planet.

Life moved on and I moved from the west coast of Scotland to the east, and married the boyfriend who had seen the same moon. One November evening I was walking the dog on the beach, as I always did, throwing seaweed around for him to chase, listening to the suck and pound of the waves. Far over the water there was a strange green patch in the sky, then a red one, hesitant at first, but glowing stronger. Was it moving? The green appeared again, then a beam came down like some celestial spotlight searching the sea. Another angled down, shimmered and moved. People were stopping at the harbour wall, pointing skywards. Then I realised what I was seeing. It wasn't the clear, rippling, kaleidoscopic displays that I'd seen footage of from further north, but beams of colour appearing and disappearing, fading out and shifting, intensifying and softening. I dashed home, knocking on doors of anyone I knew along the way and pointing at the sky like a crazed evangelist: "Look! The northern lights! Aurora borealis! It's *here*!"

We drove just out of the small town to see if the view was clearer away from streetlights, then decided, though it was after midnight, to call for my mother who lived in a nearby village. She was unfazed by the tap on her window. "Mum! It's the northern lights!" We wrapped up and sat out in her garden, gazing skywards as the celestial lightshow glanced and shape-shifted above us.

Joining the Dots

Our friends had a smallholding in the Scottish Borders, far from the skyglow of the cities. They had their own pigs and chickens and veg patch, and a hammock for stargazing. They offered us a room when we visited but we wanted to sleep in the van. They understood that it was no lack of gratitude for their hospitality but a luxury to sleep outdoors in the actual dark. By this time we were living in the centre of Scotland where the night sky is always stained by an urban sprawl of over-lit buildings and a nearby oil refinery. After dinner I went to check on the chickens and it was unexpectedly bright as I made my way down the path. I looked up and there were stars and stars and stars, then a huge streaky smudge across the sky right above me. The light was actually coming from that! The Milky Way, shining down on the rocks and trees around me. I got that sudden perspective lurch of standing on a round planet like a small blue ball, leaning out from it as I looked from this tiny spot on Earth into the rest of our home galaxy.

Later there's a night in Pitlochry, my children already asleep in a holiday cottage one February half-term. I slipped into the garden to let the dog out before bed, and gasped at the brightness of the scene – deep snow gleaming on the ground and brilliant stars above. I decided to wake the kids, thinking how my colleague from Shetland remembers being woken at night and lifted from her warm

bed to see the 'merry dancers' as northern lights shimmered in the cold winter skies. This too was worth getting up for. The cold air was exhilarating as we stood in the garden in pyjamas and wellies, and delighted in our plumes of 'dragon's breath' reaching into the sky where the stars shone with such precision. At home I'd got used to a smudgy screen of skyglow between us and the stars. Here they were so close, so bright, like you could reach out and touch them. 'They really *do* twinkle', said my seven-year-old.

I promised them that one day we'll sleep outside with the stars and look up for as long as we want. It made my heart sing to share this moment, yet I also ached to have lived in another time. I realised that I think of these sightings – rare, over the course of a mostly urban life – as if the stars or moon or whatever I'd glimpsed in the heavens were *there*, a revelation tied to a particular earthly location like a field in Lancashire, a smallholding in the Scottish Borders or a hot pool in New Zealand. Of course, they're always there, it's our view of them that comes and goes, and mostly they're eclipsed by too much artificial light. Once upon another time this was normal, a sky full of stars was part of an everyday night.

Back in the field at Girl Guide camp, that summer night as a schoolgirl, I'd wondered who had 'joined the dots' to make the shapes in the sky?

Joining the Dots

Who decided which stars belonged with each other in a constellation? Which names stuck around for thousands of years? Were some stars just hanging there in between the shapes, drifting and nameless? Questions swirled through the night sky...? Did different peoples, from different times, join the dots differently? Could I?

Yes, I discovered many years later, first studying social anthropology and then hearing speakers from around the world at dark sky conferences. Yes, people have been joining the dots since the beginning of time and from every corner of the earth, sometimes with astonishing similarities between their interpretations of the patterns, other times with delightful varieties. The bright stars in the cluster that we call Pleiades, and we name from Greek legend as the 'seven sisters', are elsewhere known as seven orphan boys, seven wives and seven chickens.

What we see as constellations are, of course, something of an optical illusion. The stars may have nothing to do with each other out there in space, and be light years away from each other. It's just that from the sightline of us Earthlings, stars of a certain intrinsic brightness appear connected and arranged in a distinctive pattern.

I learnt from the work of US astronomer John Barentine[1] how our modern map of eighty-eight constellations wasn't agreed until an international

astronomy union convened in Europe after World War One. Previously, the names and boundaries of constellations depended on who drew the star charts and how they had joined the dots. These were the accumulation of collected observations, mythology and folklore through the ages. Sometimes the chart-makers added their own constellations in a bid for recognition; sometimes the same stars appeared in different constellations. All in all, it was confusing for astronomers. As a solution, a canon of official constellations was agreed and published in 1930, mapping the sky into distinct boundaries with each star belonging only to one. Some historic constellations were lost in the process, and as ever the decisions were influenced by the patterns of power, beliefs and political tensions of the time. Some constellations named by German astronomers were deliberately discarded, and it was a distinctly Western canon that drew heavily from classical mythology and excluded those constellations that were not Western in origin or otherwise introduced by Europeans. This canon has been accepted internationally and the term 'constellation' has come to mean these set areas of the sky and the stars with them. 'Asterism' however is a freer term meaning a group of stars as we see them. The Big Dipper or Plough – or saucepan as I'd seen it – is 'only' an asterism, within the large

constellation of Ursa Major (named by Ancient Greeks as the Great Bear). Asterisms have no official status and so in theory anyone can identify them and name them. Anyone! Like me. Or you.

We join the dots because we are inherently shape-finders, story-makers, question-askers and dreamers, but also because the sky and the stars and all celestial happenings had such great significance throughout most of human history. For people, as for the rest of the natural world, the cycles of the sky told the time – through the day and through the year. For example, the Pleiades' arrival in the sky (in winter in the northern hemisphere, and departure in the spring) was an important turning of the calendar and noting it was crucial for the timing of hunting, ploughing, sowing and harvesting crops as well as for navigation.

A flick through a chronicle of astronomical events shows how intrinsic the night sky has been to the human world since the earliest records of our species.[3]

Markings on bone tablets found in the Dordogne, France from 30,000 BC are thought to represent the full and new moons – perhaps the earliest calendar. In 600BC, a chart was drawn in China containing 1,460 stars; other Chinese records show constellations grouped as far back as 2637 BC. Ancient peoples around the world built enormous structures

of stones to align with precise moments of celestial activities: The Ring of Brodgar, a stone circle in the Orkney Islands, dates from 1700 BC and shows the phases of the moon. Fragments of a bronze belt from Armenia from around 1000 BC showed the sun, the moon and animals served as a lunar calendar with 12 months and a seven day week, with the year beginning from the Spring Equinox.

We humans have always been observing, recording and calculating, trying to understand the night sky and its relationship to us. The Ancient Greeks noticed a set of five celestial lights that didn't follow the regular patterns of the stars moving across the night sky, and saw them as wandering stars: 'asteres planetai' from which the name 'planet' comes from. People used whatever knowledge and understanding they had from the time they were living in to map and conjecture, aligning their explanations to what they saw in the sky according to their worldviews.

Long before the development of telescopes, observations were made with the naked eye and all manner of ingenious instruments were created to assist the process. Astrolabes, quadrants and armillary spheres were in use for thousands of years and around the world, to measure, map and predict the position of celestial bodies. In the late 1500s, the Danish astronomer Tycho Brahe established an

island observatory where he constructed and developed a range of such astronomical instruments to chart the stars with remarkable accuracy for his time. Through meticulous observations over decades, he measured and recorded the stars, planets, moon and sun, leading to significant discoveries and cataloguing the positions of a thousand stars.

The first telescopes were built in the early 1600s, changing our view of the universe forever, and so our perception of the place of our world within it. We could see the textures and landscape of the moon, note that the wandering stars were planets and that there were more than five of them, and begin to calculate the astonishing scale of space. Galileo's telescope enabled him to understand with certainty that the earth revolved around the sun and we were not, after all, the centre of the universe. From crude beginnings of tubes and lenses, telescopes steadily developed in magnification and capacity, enabling observations with ever-increasing reach and accuracy. Now we have telescopes that can see billions of light years away, and astronomy has gone beyond collecting information from visible light to detecting other parts of the electromagnetic spectrum, such as radio waves, gamma rays, X-rays and infrared.

We're still learning, observing, measuring and mapping, expanding our knowledge ever further

along a journey that's as long as human history and that we will continue on forever. Yet we're in a strange time and place along that route. We have unprecedented access to information about the heavens and yet unprecedented loss of the necessary darkness in which to observe it for real. Most of humanity now lives under light-polluted skies in which ever-less stars are visible. Many children are growing up without ever having seen a starry sky.

My daughter has a wee telescope and can admire the surface of the moon from her bedroom window. When I was about her age, and lying in a field in Lancashire, I couldn't even imagine having a mobile phone, let alone an app that tells you which stars you're seeing. Now you can just pull your phone from your pocket, point it at the sky and instantly get the names and stories of the stars above. Instead of wondering, you'd have just Googled Cassiopeia and learned that the 'W' represents the Queen of that name on her throne, and that it was one of forty-eight constellations described by the second-century Greek astronomer Ptolemy. You'd then be lost down a fascinating online rabbit hole, reading how Cassiopeia was banished to the stars as a punishment for believing her daughter more beautiful than sea nymphs... then how the shape represents a camel in some Arabic societies... then.... But you'd be looking down and not up.

Does the instant access to information displace the time spent wondering, and in wonder? I hope we can find a way to take all that technology offers us, download the apps, visit the observatories, join local astronomy clubs and marvel through sophisticated telescopes at close views across mind-boggling distances of space and time. Yet somehow also keep looking up, finding time and space to spend just gazing at the night sky. It's called the 'naked eye' for a reason; there's an exhilarating intimacy and immediacy in that moment when there's nothing between you and the rest of the universe.

Night Vision

"Humans *can* see in the dark," a representative from a Cosmic Campsite in New Mexico is telling me earnestly. "You just have to give it time..." We've met at a dark sky conference and he is describing the glorious view of the Milky Way from this dark sky sanctuary where the facilities are basic but the heavens are exceptional. He says it's one of the darkest sites in North America, with the nearest significant source of electric light more than 40 miles away across the state line to Arizona.

However, this status depends on what light people bring with them, and visitors are urged to protect the darkness. The experience that the campsite hopes to offer can so easily be spoiled by inappropriate torches, car headlights, mobile phones – all the excess lighting that those not familiar with dark-sky camping could inflict. A blast of bright light can wreck night vision and so the ability to see the full wealth of stars and distant objects in the sky. Walking with torches can light the steps ahead but make it harder to see anything else. It's vital to keep the dark, dark.

I'm intrigued by what he says and it resonates somewhere deep in me. Given time, can we all learn to see in the dark? I try leaving the torches behind myself, walking with my sister up the road

on a weekend away to the village that we lived in as children. Stepping beyond the last buildings and their lights, the darkness ahead feels cavernous. Step by step, we keep walking into the void, just about making out the edge of the tarmac ahead. Sure enough, it doesn't take long before shapes begin to reveal themselves. We walk further and the sky seems to slowly brighten in patches. Soon we can see the outlines of the trees – outstretched branches silhouetted in black against the not-quite-so-black sky. We walk for half an hour or so and as we turn back the black cavern is transformed into just-familiar place-markers: limestone walls, gates, trees, hedges and edges. We stop at a gap in the stone wall where we used to walk our dog into the woods, and step down off the road and into the trees. We stand there a while in silence, just waiting, breathing and absorbing the night. Right on cue there's a screech from deep in the woods as a barn owl calls, and an echo from the fields across the road.

This is where we used to walk as children and yes, this is how it was – it did get brighter and you could see eventually, if you were brave enough and just kept going. Have we all forgotten this? With such easy access to artificial light always, why would anyone even try to do without it?

I recently treated myself to a writing retreat in the Scottish Highlands, at a centre specifically specially

designed for peace, tranquillity and creativity. I was looking forward to headspace and the company of other writers; big mountain views in the day and, far from streetlights, big dark skies at night. Another participant was longing to see the northern lights, as there had been reports of active skies all over Scotland that February. In the evenings we stepped outside in search of both, everyone fumbling for the torch on their phones even as they stepped out of the kitchen door, from where light was already spilling outside. Those tiny phone torches are piercing and their sharp beams drilled like lasers into the darkness around us. Then, as we stepped further onto the lawn, automatic outdoor lights blinked on around us. They were positioned at head height and angled right into our eyes. Night vision gone. Peace, tranquillity and creativity gone, too.

We waited outside for ages, staring up in hope, willing the clouds to part and show us some stars, or better still some beams of red and green. But the clouds gathered stubbornly, hosting a smudge of skyglow from Inverness. The lights from farms and homes way across the valley were absurdly bright and car headlights bore into the landscape from roads that meandered into the hillside. I suggested maybe switching off our phones and asked whether the outdoor automatic lighting could be disabled for a while so we could enjoy the darkness.

My fellow writers were bemused. 'Errr… we do need to see where we're going,' they replied. You know those times that there's too much that you want to say, so you just sigh quietly and say nothing…?

This is what I wanted to say: you *can* see in the dark. You just have to give it time. Step outside the kitchen and pause a while. Let your evolutionary response kick in, adjusting the muscles and chemicals in those exquisitely complex light-sensitive organs that are your own eyes. First the muscles around the pupil kick in, expanding and enlarging it so you can get as much of whatever light is left. Then the colour-sensing cone cells begin to adapt, steadily increasing their sensitivity to the dim environment over the next 10 minutes or so. The more numerous rod cells activate more slowly but soon take over the task, they are far more sensitive to minimal light levels and are responsible for our night vision. Their sensitivity continues to increase for hours after darkness, as the light-sensitive chemical rhodopsin regenerates. This stuff is so sensitive that even a few seconds of bright light destroys it and then it's back to square one, needing a good 30 minutes for dark-adapted vision to recover.

So switch off your phone! Tape up those outdoor lights! Look distant and look close. It comes gently. Shapes emerge, take form and substance. You can

discern the bulk of things, the edges. Listen, feel your way, and reach out. Our vision can stretch way further into the darkness than most people realise. It also steps back as other senses awaken and sharpen. That's part of what makes being out at night such an invigorating experience. Smell the air, feel the texture of it against your cheeks and as you breathe it in. Listen. Whether the sounds intrigue or spook you, keep listening. You come alive that way. Trust the night, I want to say. It's an old friend, not a foe. Trust yourself, too. Trust your feet to find their footing in very little light.

Because that's what it is: very little light. That's what we're normally experiencing when we describe it as darkness. Our eyes function by detecting light so no, we can't see in total darkness, which is an absence of light. But there is rarely absolute darkness even in the natural world, except in deep caves and very deep in the ocean. Otherwise 'dark darkness' is transitory – a moment on a moonless night with thick clouds. Mostly there is an ever-changing shifting motion of different levels of light through the night. This is shaped by a number of cycles: the phases of the moon, the seasons of the year, as well as the weather, as clouds gather and drift apart. It varies not just by celestial activity but the environment that the natural light at night falls upon: whether snow, water, wet or dry ground, shiny or matt leaves.

Many other species can 'see in the dark' we're told, but what they're also doing is detecting and using very small amounts of light. Some nocturnal animals have a reflective surface behind their retinas so that they maximise any light available. Others have evolved to have extremely large eyes for the same purpose.

Our very definitions of light and dark are utterly inadequate given the complexity of life's interactions and the enormity of our combined experience. If darkness is the 'total or near total absence of light', what, then, is light? Various dictionaries attempt different levels of explanation: 'the brightness that allows things to be seen'; 'the agent that makes things visible'; 'electromagnetic radiation which is visible'... None of them quite suffice, as all beg the more important question: seen by whom? Or what? And how? It's clear that the way we define light and dark is all about human eyes, and so not very helpful for understanding the experience of the wider world. If light is defined by vision, what is it if you're a tree?

And what is this electromagnetic spectrum, of which a tiny, rainbow-coloured sliver we humans call light? It's energy, pulsing and fizzing throughout our world and way beyond it into the universe and even way beyond that. Scientists have long debated whether it consists of waves or particles, and seem to have concluded it is neither and both.

It is a multi-faceted mystery which, in different conditions, sometimes behaves in wave-like ways and other times in particle-like ways.

All the same, we measure aspects of it in wavelengths: the shorter the wavelength the more intense the energy. We define these waves by the ingenious uses that humans have found for this energy. The longest waves commonly used are radio waves, coming down to television waves then microwaves. Then infra-red waves, which are just beyond the vision of humans but not the perception of rattlesnakes. Next on the spectrum is the small section within human vision, which we perceive in terms of colours, from longer-wavelength red and orange, through yellow and green, to shorter-wavelength blue and purple. Then on to ultraviolet (UV) light, which is beyond human eyesight but an important part of vision for many birds and insects and their interactions with plants. Ever shorter, and higher in energy, are waves that we describe as 'x-rays', then gamma rays, then.... It goes on forever in both directions, as far as we know, and there are no precise boundaries between any of the sections. Some physicists call it all 'light' and there is a case for that, as the divisions are arbitrary and human-centred.

It's important to understand how other beings perceive light if we are to grasp the true implications of an over-lit world. Many species can detect

energy beyond what we call visible light. Life has evolved an extraordinary variety of light-detecting mechanisms, manifest in many forms from deep-sea fish to insects to plants. Eyes are only one method, and human eyes only one of many millions of these complex organs. Even our understanding of human vision is still evolving, with much still to learn. Insights on the role of light in the natural world are constantly being discovered. Who knew that the bills of puffins and the fur of duck-billed platypuses glow in UV… why would that be? What can perceive that? What else don't we know?

Ecologists are now calling for ways of describing light to be made relevant to the species in question. What *is* light and what *is* darkness will vary according to perception. For example, scientists studying marine turtles talk of the 'full moon equivalent'. The colour, intensity and brightness of the full moon is the light that's most meaningful for turtles. They come ashore to nest on sandy beaches and, as the hatchlings try to leave that beach and head to the ocean, they are guided by the moon's light.

For many creatures, what's most relevant to their wellbeing is the amount of light that supresses the hormone melatonin. Known as the 'hormone of darkness', it regulates many aspects of the way the body and mind functions, including sleep, the immune system, and reproduction. New research

keeps showing that the amount of light that affects melatonin levels is lower than we expect. The gleam of moonlight (or artificial skyglow) on the water's surface alters melatonin production in the fish below. The level of light required varies hugely in different species, and so we need to think of light in terms of the perceptions of the plant, animal, fungi or fish that responds to it.

Our own response in adjusting to darkness can sometimes seem frustratingly slow. It can be startling when we step between a dark cinema and a sunny street, or scary when a sudden thrust of bright car headlights comes over the crest of a hill, dazzling and diminishing vision while driving. Why does it take so long for our eyes to adapt?

Because the mechanisms in our eyes for night-adapted vision have been in place in vertebrates for 50 million years: the pupils dilate, the cones get more sensitive and the rods continue to sharpen long into the darkness. It makes perfect sense in evolutionary terms when dusk and dawn softened the boundary between light and dark, and night fell incrementally. Our eyes were simply created for a gentler transition.

Take it slowly and their capability is surprising. I've found it exciting to discover a capacity that I didn't know, or had forgotten, that I had. When I have six million cones cells fully activated, they

provide pretty impressive night vision. And not just for walking out into the night but pootling around in the house. I have realised I don't always need to put the light on, and need less light when I do.

The speed of adaptation and extent of night vision differs in each of us. Try it for yourself and explore your own capacity. Step into the night, one step at a time. Just give it time.

The Luxury of Dusk

I wish I could tell you I'd driven into the wild to satiate my craving for darkness, and stepped out alone to embrace the night with open arms. Or that I'd climbed a mountain and pitched camp so I could reach for the stars from the top, or maybe parked my van on the shore way out west to watch the moon gleaming on a remote sea loch.

I hope I will do all these things one day. I know women who do and I admire and envy them in equal measure. Being out at night alone still scares me, even with the dog at my side. I want it hugely, like a hunger, but my fear is even bigger. That edgy alertness, the prickling unease running like a current under my skin, how do you sleep through that? Maybe one day I will.

Meanwhile, I park in a city garden by the river. I close the gate behind me and my friend is in the house nearby. I feel good here, safe, and deeply grateful for the gift of access to this garden, to be able to walk around it at any hour. I've discovered a freedom here, to be alone, to walk step by step into the darkness and enjoy the night. This luxury of space and stillness is all mine tonight.

It's hinting towards evening already, the colours strengthening and softening, I make my campervan bed early. I spread out my sleeping bag and lay a soft

blanket over it, set my torch and water bottle on the shelf nearby. What else do I need? Nothing at all. Just to be here.

When I duck out of the van door the colours are sweetening and quieting further, like a dimmer switch being nudged down very slowly. I realise the enormity of another luxury that is mine tonight. Dusk. This liminal zone between day and night should be, and once was, part of the normal daily cycle of time, but we rarely get to experience it any more.

It feels like the human world is poised on a hair trigger to ward off darkness. At the first delicate inkling of dusk, lights flicker on all over the place. Click, click, click, the soft, almost imperceptible announcement as streetlights switch on all over the city. Bike lights shudder and pulse brightly and external lighting pings on around houses, churches and public buildings, as the air around them sharpens and the daylight softens. There's no space left, not even a breath for dusk; it's squeezed out and snuffed out by this barrage of light as soon as it appears.

But tonight there will be dusk. We're going to spend time together, me and dusk, we'll hang out with no time pressures and get to know each other a bit. I sit under an apple tree, waiting expectantly, and right on cue three bats arrive out of nowhere and herald dusk's arrival with their flickering dance, looping into the trees and out over the lawn.

The Luxury of Dusk

I get up and walk through the dusky garden in a bounding stride, feeling giddy with the sense of space and time and freedom. The expansiveness is so delicious that my arms swing around as if I'm swimming through it. A sudden movement draws my eyes to the long grass where a tangle of branches and dead wood create a patch of wild scrub. I stop. A handsome fox stops too – staring right at me as if wondering what this strange half-dancing, half-swimming creature is doing in *his* garden. We are frozen in time, neither of us making the first move. I'm looking right into his dark and shining eyes. He's astoundingly beautiful: his coat is rich and glossy, ears dark at the tips, and his flamboyant tail poised as if resting on the long grass beside him. I've always thought that foxes have the best of it all – feline grace and canine charm, and even among his kind this is one gorgeous creature.

The city foxes around here obviously find what they need in these riverside gardens and seem to have little to fear. They're not just glowing with health but cocky and nonchalant. If you pass them on the riverside path they stroll on by, with that easy loose stride, maybe pausing and glancing as if to query your presence. Maybe I moved, or gasped in my appreciation, but he suddenly whips around and slips across to the other side of the garden, the remaining light shining on his chestnut coat and the white of his tail.

I walk on, more sensibly, as if gently chastised by the fox for my daft movements. Light is fading faster now in the dark areas of the garden under the trees; the wild edges are losing definition while the remaining light gleams on the lawns where the bats are still circling.

Occasional boats come and go on the river, and flotillas of swans drift by, their whiteness brightening somehow as the light fades. I can hear a throb of traffic that seems far away, the city rumbling on somewhere beyond. The sounds in the garden are sharper, more immediate: a crackling and scampering in the trees beside me, a flurry of flapping. I presume it's just squirrels jumping from branch to branch and wood pigeons flustering, but still feel an edgy alertness start to prickle in me at the closeness of the noises around.

Across the river we're blessed with stretches of common ground, wild and spacious enough to host sparrowhawk nests in the trees and water vole burrows in the banks. On that other side, the lights of bikes flicker and judder along the paths, and I'm grateful for the distance so they don't intrude on my time with dusk. Something else comes from across the river, distant but welcome, and I stand perfectly still and reach with my ears towards it… hoo hooo, hoo hooo. Tawny owls are calling on the common over there, their wavering

voices rippling over the water and reaching into the approaching night.

Would I sit across there now on that dark common? A few streetlights light the paths, but in between are big triangle-shaped stretches of darkness. I cycle that way home sometimes, stop and switch the lights off and look upwards. There are stars right here in the city. Those dark riversides offer space enough to see the main constellations. But no, I wouldn't sit out there now, alone, like I'm doing here. I know from reading many a study that light and dark have more to do with the perception of safety than any real danger for women, but still... Here I'm shielded from my own fear by a great big bubble of perceived safety.

The colours are going, going, gone now. Even the rich red leaves and bright yellow summerhouse all muted and heading for monotone. Patches of light still hang in the sky and glimmer on the lawns but the stars are appearing above me one by one. I greet each familiar constellation in turn as they reveal themselves, and walk slowly across the dark garden to my campervan bed.

I settle to sleep with the window open beside me, delighting in the night air on my face. There's scampering and scrabbling above but I know it's squirrels in the big walnut tree; I had seen them rippling along the fissured branches all day. I know that the

occasional pitter patter that sounds like erratic rain is the soft green crumbs of walnut shell falling on the campervan roof as the squirrels grasp their prize with both hands and nibble away.

These are the sounds that will lull me to sleep and I smile as I drift away. Yes, I know, I know, that grey squirrels are an invasive, non-native, nuisance species. But still – whisper it – they delight me, and always have done, ever since I was a small child visiting my grandma in London and being taken to Regents Park, where I would spend patient hours waiting for the squirrels to come down from the trees and take nuts from my hand, thrilling at this close encounter with something wild.

And here in the garden I love how they bring perpetual motion to the scene, flowing along and between the trees, always on the move with such ease and speed and such lightness on high, delicate twigs. So I'm smiling at squirrel ripples as I drift off to sleep, feasting on night air, fresh and present and sweet-scented.

I wake to a snort. Then something like a human cough. It's very close by. I hunch instinctively in my sleeping bag, every cell of me alert. There's a loud crunching and shuffling from the wilder scrub area beside the path – it's pitch black there. Then silence. Was that a dream? No, I'm awake, wide, wide awake, and there it is again. A heavy sighing

then something like a cough, *huff* and again *huff*. It's something large, I can tell from the weight of the sound. Are there badgers around here? I've seen muntjac deer wandering through the gardens, but this sounds more solid and substantial. A person, hiding in the dark bushes? What would they be doing here? Waiting to break into the house? There are no lights on over there so my friend must be asleep. A cough-sigh again. Maybe a drunk guy wandered in and is stumbling around?

My fingers explore the dark surface beside me and grasp the torch. It's one of those big ones like a police truncheon. I can hit with it if needs be. A huffy cough again, like someone clearing their throat, and a crackle of twigs and a shuffle. So close yet I can see nothing out there. Too close. Something or someone is approaching the van. The thud in my chest gets louder. Act now. Grab the torch, shine it in their eyes, scream if necessary – there are houses around, someone will hear me. I sit up. Point the torch out the window in the direction of the sound and switch on the light.

Silence. The scuffling and snorting stops abruptly. In the yellow pool of torchlight a hedgehog has stopped in its tracks. It's utterly still but not retreated into a ball of spikes, just paused as if waiting to see what happens in this surprise light. Then it shuffles on unexpectedly fast, its long length lifted

up on small legs and moving across the gravel path as if on wheels, scrunching and crunching noisily as it does so.

I'm shaking slightly and start to laugh out loud. I'm awake now and need the toilet – I pull on my wellies over my pyjamas, walk toward the outside loo, watching my hedgehog neighbour trundling along across the path and away towards the other side of the garden. When I come back out it's gone. I walk to the lawn and look up to see the stars all over the dark blue sky. It's cold and adrenalin is still prickling through me so I do a little dance on the grass as I toss my head back to admire the sky. The fox can think what it likes; it's my garden too, tonight. Still, I'm shivering, so I soon return to my sleeping bag and, with the window still open, drift off to sleep.

I'd planned to spend time with dawn too – it's as magical and necessary as dusk. I'd hoped to watch the colours arrive and slowly brighten through the garden. But I wake late, with bright sunlight streaming onto my pillow and the squirrels chasing each other, skittering along the branches in the walnut tree.

Wild Geese Calling

I keep writing, though I don't even know if this page has words on it already. I can't see my notebook anymore in the darkness of the hide. Maybe words are falling randomly on my page, overlapping in layers and forming shapes and patterns. Dark marks on the light paper, with clusters then stragglers, like this new line of geese coming down from the sky, calling.

'Babble-chatter', that's what my daughter used to call it, when we'd hear them flying right over our house in the autumn. The excited honks and squawks would always call me outside. I'd stop whatever I was doing and rush to the backyard, looking up, uplifted to see the long, flowing, shifting lines and 'v' shapes forming in the sky. Often I'd wake in the night when they passed overhead, and I'd smile in the dark at their babble chatter.

They've been coming in, calling, in intermittent waves for a few hours now. My photographer friend and I arrived in the still-light and settled in this hide, set back a bit from the water's edge. We're now keeping watch over a small loch in a wild expanse of moorland as it fills up with pink-footed geese. They shelter here in the Scottish Borders for the winter before returning to breeding grounds in

Iceland and Greenland. Looking out through the frame of the narrow wooden window, the landscape seems arranged in layers: streaks of cloud and sky and land in muted shades of greys and yellows.

The geese come in from behind the hide so we hear them first, announcing their arrival with animated conversation. Then we look up to see outstretched wings above us as small gangs flow in like a current. They circle the water together in a big curve, perusing for a landing patch. Then down they come – seeming to pause in mid-air and make their way down from the sky in side steps, tipping and tacking in strange postures. 'Whiffling' it's called, the way geese brake to speed their landing. There's comedy in the incongruity of awkward shapes and chaotic patterns after the grace of synchronised skeins. It makes me think of that iconic quote from the film *Toy Story*: 'that wasn't flying, it was falling with style'.

Gulls are coming in too, silently, drifting as if blown in the wind. They seem to alternate: a surge of babbling, cackling geese then quiet clouds of gulls. More and more of both arrive in ever-larger groups as the sky darkens and the reeds around the edge of the water become silhouettes.

The land all around is black now, just a streak of light and suggestion of colour on the loch. The wind scurries on the surface and sends tiny dark

wave-lines rippling towards us. Over on the far side, the patch of light is filling up with black dots as birds settle on the water. The photographer is experimenting, surprising himself, pushing his camera to the limit of what light it can detect and what shapes it can discern. I'm experimenting too, trying to keep writing beyond my capacity to differentiate black ink from white page. I've no idea if I'll be able to decipher any of it when I look at my notes the next day.

No matter, geese have been done anyway. What more could there be to say? For me, the poet Mary Oliver captured Wild Geese so entirely that it's her words I hear through their babble-chatter. On October mornings when I'm dashing for the bus to work and geese are calling above, 'You don't have to be good' is what reaches me from the skies and I feel my shoulders drop with relief. When I wake in the night and hear them, they tell me, 'you only have to let the soft animal of your body love what it loves' and I smile and snuggle in closer to the warm body beside me. They come every autumn to 'announce my place in the family of things'. It's ok to be here. It's ok to be me. Their calls fill the evening skies: it's ok, it's ok, it's ok.

You don't have to be good, no, but to me they are goodness, somehow. With seasons skewed by climate change and strawberries in the supermarket all

year round, our sense of time and place can feel out of kilter. The arrival of geese each autumn floods me with a feeling of rightness and relief. They tell me of the seasons turning, the air sharpening, the colours sweetening. Soon the blackberries will be ripe and the garden hung with spider webs. 'Meanwhile the world goes on', they say.

When my children were little, we'd make a pilgrimage each year to see thousands of pink-footed geese pour out of the autumn skies over Aberlady Bay in East Lothian. We'd arrive in the light and settle on the shore, all around us the orange clusters of sea-buckthorn berries bright among their silver-green leaves. We'd scan the skies – see a faint line far in the distance, could that be streaks of cloud? Then the line would thicken and flow like a ribbon, darkening and revealing itself as geese. Line after line would come, moving over the surrounding farmland like an approaching army, closer and closer, until we could hear them calling.

One year we lay on our backs in a nearby field and watched the pink sky as an evening-full of geese flew in. One line, then silence. Then wait, listen, another arriving. Over and over in succession. We waited and watched through the long autumnal dusk until the darkness was so thick we couldn't see them in the sky or on the water anymore. But we could still hear them. 'They sound like they're

going to a party' said my young son, as they filled the air with exclamation and raucous gossip. As we made our way home, an enormous Hunter's moon was rising. From the carrier on my back, my daughter pointed at it and squawked like a goose. 'Moon dirty!' She complained, as dusky clouds drifted across the astonishing orange circle.

There's something about geese. People not normally given to saying such things have described watching them as a spiritual experience. Maybe they call us outdoors and make us look up, be present in the time and season, take us through the dusk to the night, accompanying us with their calls. Maybe they tell us of journeys, too, of arriving and leaving, coming and going, the inevitable circle of things. Writing in the dark in the hide, words that land on random lines on my page: 'I'm cold but happy alive, awake for first time in way too long'.

It seems pitch black outside by the time we leave the hide, but we agree to leave the torches off and see if our night vision can get us back across the moor. As we set out, some of the clouds part and reveal a big yellow moon hanging above the silhouette of a tree. The photographer takes off at surprising speed, crossing the dark moor in long strides to seize the moment from the right angle. I make my way gingerly over the boggy, uneven ground, stumbling on tussocks of grass, determined not to give in

to the temptation of the torch in my pocket. I can't see where my feet are going but, high above, stars are appearing through the drifting clouds. Looking back, I can't see the hide that we've just left, but the geese are still calling.

Writing the Night

I'm a bit of a night owl and aware of the irony of this. I'm so often working late, writing about the importance of morning light and how artificial light in the evening messes with your body clock. And yet I like to write at night. Words flow easier. It's partly the logistics of this stage of life when the rest of the family has gone to bed and the house has that settled calm. Yet I've always found the night to be a more creative time, somehow there's more space and so my mind feels free to wander.

How I envy morning larks. The writing world online is full of guidance about rising with the dawn, or setting an alarm even 15 minutes earlier to steal some precious writing time before the busyness of the day intrudes. Apparently you're more lucid then, closer to your dreams. I've tried it, honestly, I have. I can barely even open my eyes as my arms flail about to silence the beeping of the alarm clock. I stare at the blank pages and yawn like a donkey, my pen so cumbersome in my hand. Gravity feels excessive, astonishing; I haven't even stood up but it's dragging me down and sagging my mind and body until I'm thinking through sludge. I push the pen onwards, laboriously finishing the requisite number of words or

pages, wondering if flashes of inspiration will burst through like morning rays of sunlight through a gap in the curtains. Nope. Just sludge.

But come the night, when the chores are done there's a sudden upbeat of expectant calm. I open the attic window and look up to recce for stars and breathe the night air. If I can be alone then, my mind can drift and words will flow and carry me away to that other place away from time and space. I can read the words another day, be surprised, annoyed, frustrated, pleased or whatever. It doesn't matter. There's always something there, a seed of an idea or phrase, a paragraph or two. Does night itself collude with the writing?

According to chronobiologists, who study the effects of the body clock, being a night owl or a morning lark is an intrinsic part of your genetic make up. You can shift it a bit, using the power of light to nudge it along and feel more awake or drowsy at certain times, but that's all. We are born with a particular type of body clock and that's just who we are. I felt quite triumphant when I heard this; it's one in the eye for the smugness of morning people who seem to feel an innate superiority throughout the day just because they got up earlier. It's good to know how you feel in the morning is not a choice or a morality signifier, but written in your chromosomes.

Beyond genetics and the body clock of night owls, is there some deeper connection between creativity and the night? Author Jeanette Winterson thinks so: "to sit alone without artificial light is curiously creative," she wrote, in an article celebrating winter darkness. "Night and dark are good for us. As the nights lengthen, it's time to reopen the dreaming space…" (in *The Guardian*, 'Why I adore the Night'.)

Georgia MacMillan, a Dark Sky officer in the West of Ireland, has had her work cut out championing dark nights in one of the last places in Europe to get electric lighting. "Surely we've had darkness long enough," she's often told by older residents. Light at night is widely welcomed as an intrinsic part of modernity and especially valued by those who remember much more prolonged darkness. Yet the experience of dark nights is intertwined with Ireland's long history as a place so rich in stories and storytelling. "There's a quest for mystery that would not be satisfied in too bright a light condition," octogenarian local historian Gerald O'Brien told Radio 4's *Nocturne* series.[4] Describing traditional gatherings around large turf fires in the evenings, he said, "most of the great storytelling all over Ireland would be conducted in that atmosphere."

An elderly relative of O'Brien's would travel around Ireland telling stories. "She didn't have to compete with electricity," he explains. "The change

from day to night and night to day to her would have been invested with wonder, which eludes most other people. The day has been elongated with the electrification of rural Ireland. It has destroyed the experience of night in the modern age – and I miss it a lot nowadays, because I haven't had it in forty or fifty years…"

The Dark Sky movement in Ireland is not, of course, advocating a return to a time before electricity, but seeking to find a balance that still allows space for – and enjoyment of – dark nights in the modern age. This involves the creation of reserves and dark sky areas where external lighting is kept soft and low to allow the stars to shine and creativity to flourish. For example, Mayo Dark Sky Park is set in the west of Ireland between the Wild Nephin mountains and the Atlantic. Its 'stargazing checklist' includes reading WB Yeats' *Fairy and Folk Tales of Ireland* alongside the practicalities of binoculars and warm clothes. The programme of events and regular festivals acknowledges the importance of dark skies for human wellbeing and culture. Together with astronomy-focussed events such as guided stargazing and meteor walks, there is also music, poetry and songs. As well as drawing from Irish traditions, some events include stories and poems from culturally different perspectives to further explore the meaning and value of dark skies. In

Mayo's annual Dark Sky Week, writers and reciters are invited to share works inspired by the beauty of the night sky.

Of course, the night itself has long been a character in our stories, myths and legends. Follow the long threads of stories through cultures and stop at any time or place and you'll find the night sky there. The moon and stars feature prominently in tales told throughout the world and all through history. I collect such moments, snippets of quotes and poems, when I randomly encounter them and keep them in a notebook beside my bed – my personal, hand-written, dark sky anthology.

There are fragments of poems from the Ancient Greek poet Sappho in the seventh century BC that note the Pleiades setting, and celebrate the wash of clear silver moonlight that floods the earth and diminishes the stars.[5] The Chinese poet Li Bai from the 700s AD wrote in 'Thoughts in the Silent Night' of moonlight shining like frost on the ground and imagined the homesick longing for his hometown when he looked at the moon.[6] In the ninth century, Chinese poet Li He wrote of the Milky Way as a river of heaven, which turns in the night and floats the stars.[7]

On to 1850s America, Walt Whitman wonders at the miracle of 'Stars shining so quiet and bright/ Or the exquisite delicate thin curve of the new moon in spring.'[8]

In 'On the Beach at Night', Whitman watches stars and contemplates enormity and eternity, within the 'vast similitude that interlocks all'.[9] Emily Dickinson wrestles with the impossible scale of space in 'I saw no Way – the Heavens were stitched', yet finds a way to reach through and connect: 'I touched the Universe'.[10]

In the 1920s Robert Frost plays with perspective in 'The Freedom of the Moon'. Walking slowly in the evening he can view the moon over trees or water, as if has agency to 'try it', pull it or even drop it into water and 'put it shining anywhere I please'.

Closer to home, my favourite band the Saw Doctors capture the delicious peace of being alone at night in their song 'Stars over Cloughanover':

Scents of Summer
Are all around me
I've left the talking behind
Walking slowly
I'm in no hurry
The night-time sky is mine.'[11]

And yet closer to my home in contemporary Scotland, I can taste the night air in Paula Jennings' poem 'Spring Again':

At moonrise star particles glint
in the bent horns of trees,
barks of foxes charge the night.[12]

On and on we write the night, the notebook
beside my bed filling up with these evocative descrip-
tions, to the extent that Scottish poet Claire Askew
starts the first stanzas of her poem *Bad Moon* with the
line: 'The moon must be sick of being in poems…'![13]

As for darkness itself, the shared cultural ref-
erences in the storyland of our hearts and minds
have a lot to answer for in influencing our attitudes
through the ages. The metaphor of light as good
and dark as bad is so pervasive that it settles deep in
the subconscious. It resonates of course with a deep
and primal human sensation – fear of the dark and
the night. Fear renders darkness sinister and evil.
It's a metaphor threaded through the Bible, but
for me epitomised in the imagery running through
Shakespeare's *Macbeth*, where the coming of night
brings an ominous sense of doom:

Light thickens and the crow makes wing to the
 rooky wood
Good things of the day begin to droop and
 drowse
while night's black agents to their preys do
 rouse.

Light – including the natural lights of the night – is seen as honest and good, a truth-teller that reveals, as Macbeth calls to stay hidden in darkness: "Stars, hide your fires, let not light see my black and deep desires…".

Now the metaphoric use has become a dictionary definition; when did that happen? According to the Cambridge Dictionary, darkness also means 'the quality of being sad or without hope' and 'the quality of being evil or threatening'. The power of this metaphor helped pave the way for (artificial) light to conquer (natural) darkness in a swift global invasion. In this way of thinking, light is welcomed as a source of goodness and virtue, and celebrated as a triumph over sinister darkness – another manifestation of human dominion over nature. And if light is good, then surely more light is even better, and then more, then ever brighter…

It's now time to write new stories, and to seek out the old ones that also celebrate the darkness and the natural lights of night. Our perceptions are augmented and amplified by the power of story. Maybe then the dictionary will include a new definition of darkness as the quality of peace and calm, being like silence to noise, a respite from light.

And if you write, or create in any way, the best way to know how your own body clock works best is simply to try it. Let the night in to your experience,

experiment with the sensation of darkness. Stay up late, or get up in the night and spend some time with the lights off to 'reopen the dreaming space'...

> The sky and stars speak no word, nothing to the intellect,
> Yet in silence, of a fine night, questions are answer'd to the soul,
> The best answers that can be given.'

> Walt Whitman, 'The Nighttime Sky'[14]

Misunderstanding the Moon

Dear Edinburgh City Council,

Further to your correspondence with Edinburgh resident John, I'm writing to ask you to consider it possible that you may have misunderstood the moon.

John had lived in his house in central Edinburgh for twenty-five years with the friendly orange glow of a traditional streetlight outside his home. One November day, he noticed his neighbour severely pruning a roadside tree. The neighbour explained that he'd been told it had to be done for the new LED streetlights. John had received no communication or consultation about the change of lights. Soon after they were installed, John wrote to complain about the new light, which he found both harsh and gloomy all at once. He drew your attention to his concerns about the impacts of these streetlights on human health, the natural world and road safety. He also told you how they more immediately affected him: he found it difficult to see in front of his house when he came home in the evening and they created a depressing night-time environment. Night, of course, beginning at four in the afternoon in an Edinburgh winter.

Your reply sought to reassure John of the environmental and aesthetic credentials of the new

streetlights. They could be seen as more 'natural', you said, because with 'a colour temperature of 4000K' they were more 'like moonlight'.

Ooft. I startled myself with the intensity of my gut reaction to this statement when I read the correspondence. My jaw and stomach clenched and my fists contracted into tight balls. Like moonlight? No, just no! Moonlight is softly bright, silvery, sexy, calming and exhilarating all at once. It beckons me to linger longer outside. These new streetlights cast a ghastly, ghostly pallor; the light is sharp and edgy beneath them, yet creepy and gloomy between them.

After the 'no', another sensation arrived like an aftertaste. I realised I felt offended, as if you had insulted a loved one and the affront had made me realise just how precious they were. I felt a surge of defensive anger.

In fact, not 'as if'; it *was* an insult to a loved one. I love moonlight and have done so all my life. It *is* something dear to me. Looking back, moonlit memories seem to gleam with an extraordinary quality of aliveness.

In my schooldays we lived in a coastal village where the streetlights stopped at the end of our road. If you went out at the weekend there were a few miles of darkness to walk between the unmanned station and the soft orange light of the

village. Moonlight was significant then, as it was for everyone once upon a time. Without it, and when I'd forgotten my torch, I would walk through thick blackness, just about making out the edge of the tarmac as my eyes adjusted. But on moonlit nights the fields beside the road were glanced with a delicate brightness that glinted on the limestone walls and edged the trunks of the silver birch trees. I'd turn a corner, nearly home, and see bright bands of pale silver lying in shining streaks across the bay.

Once, on the Inner Hebridean island of Coll, I stepped out into the brightest nightscape I've ever seen. The moon was enormous and it lit the whole world. I walked with a friend, incredulous. 'It's like day!' we kept saying, except of course it wasn't anything like day or anything I'd ever experienced. 'You could read a book!" we exclaimed, though reading a book was the last thing on my mind. You could also take your shoes off and dip your feet into that shining sea. You could take your clothes off and bathe your whole body in that strange silver, you could reach out and touch silver-glanced skin. That light fell like a blessing, on rock, on sand, on sea, on me. Everything was shining. I could have walked forever that night and I wanted to dance as I did so. I felt alive on a cellular level, pulsing with energy, an astonishing mix of deep peace and vibrant uplift.

Apologies, I'm getting carried away. I'm not actually expecting your street lighting procurement department to listen to the lunar-love ravings of a mother in Falkirk, nor to factor my moonlit moments into whatever cost to energy ratio analysis informs their decisions. But please hear me out: I was intrigued by my own response, to your correspondence and the light that ignited it. I knew what I knew experientially, felt it in every part of me – in my cells and in my soul – and it made me curious about the science. This energy, in the form of light, what *is* it, and how does it vary? What actually is the difference between the light that comes from John's new streetlight and the light that reaches us from the moon?

Because I'm an inquisitive kind of person, I started and didn't stop, my questions only led to more and more. I asked street lighting engineers, lighting designers, circadian biologists, astrophysicists, bird song experts, ecologists, neurologists, quantum physicists, photonics specialists, cultural astronomers…Can I tell you what I found?

So firstly, this '4000K' business. I asked: how does light get a number and a letter, and whatever does it mean? I learnt that with light we use a concept of temperature to describe an appearance of colour. The 'K' refers to Kelvin, a scale named after Lord Kelvin, the nineteenth-century Glasgow

professor who came up with this concept of 'colour temperature' based on comparing the colour of light to metal in a forge. It's kind of counter intuitive to the non-scientists and non-blacksmiths amongst us who think of red as hot, but actually the hotter it gets, the paler it becomes, from deep glowing red to 'white hot'. In streetlights, 2700K would be a warmer colour, while 4000K and above is whiter in appearance, towards the blue end of the spectrum of energy that we perceive as visible light.

Ok, so John's streetlight is described as 4000K. Moonlight, which is of course reflected sunlight, is also described as about 4000k. Therefore, the new streetlights are 'like moonlight' – right?

Wrong, because this 'K' is only one aspect of how light appears and is. The main takeaway from my deep forays down multidisciplinary rabbit holes is this: light is mighty complicated. It's an exceptionally multi-faceted and mysterious energy that we as a species are only beginning to understand. The things we learn at school in physics lessons, about photons and frequencies, are only working models, metaphors to help us to grasp towards the gist of how to work with it. Apparently Einstein himself said those that think they understand light are kidding themselves.

That's what the quantum physicists told me: there are many aspects of light that can be measured

with exceptional precision, but any measurement is inadequate because it's only one part of the story. We will be inevitably be missing something out.

Colour temperature only tells you the gist of how a light renders when perceived by human eyes. It can be a useful tool when comparing similar and so directly comparable light sources, such as when buying light bulbs for a particular fitting. But like I said, the LED streetlight and moonlight are not alike. Exploring other measurements and other facets of light makes this apparent.

Let's start with the differences that are most obviously apparent, yet still important to note. Firstly, there's shape: the moon is round, and the reflected light shines uniformly all around, becoming softer over distance. The LED streetlight is flat, made from semiconductor chips that produce an intensely directional beam of light that's concentrated at the centre. In this respect, LED lights are not only different to moonlight but to all other light sources except lasers.

Then take distance – one is a 6m pole on the corner of John's street and all over town, the other is reflected light from the sun bouncing off a big grey rock some 300,000 miles away. This means that when you are near them, LED streetlights are far, far brighter than moonlight. I'm learning that there are lots of different ways of measuring

brightness, but suffice to say that this brightness is fiercely intense and utterly unnatural.

Also, the colour that light appears as is not the same as the colours, or frequencies, that the light actually contains. What appears to us as white light is actually a mix of different wavelengths of energy. If you were to draw the curve of a colour spectrum from red to blue, moonlight would be a smooth curve containing the natural full spectrum of colours, with plenty of reds within it (our eyes just don't see it that way). The 4000K streetlight however has some colours missing, and a 'hump' and spike in the blue end of the light spectrum (the shorter wavelengths where energy is more intense). These curves are known as the Spectral Power Distribution (SPD), which is another way of describing the colours of light.

So, light isn't a colour temperature or spectral distribution or brightness or intensity or glare or directionality, it is all this and much, much more. All of this matters because light and darkness matter far more than we realise. My other big takeaway from this research is that we (by which I mean 'we' as species, a society, a city, a council, a street lighting department...) have grossly underestimated the power and importance of light and its essential dance with darkness. Upset the balance between them, and we upset the clock that life on Earth is scheduled by. The perpetual rhythm of light and darkness is the

beat that ensures everything steps in time: the plants, insects, birds and fish as well as us mammals.

By lighting the night we have lost the darkness and lost touch with the moon. The implications of this for the living world are currently the subject of much scientific exploration and concern. At the heart of it is the circadian rhythm or body clock, which governs not just sleeping and waking but the physiological processes that take place during the night's rest, whether in humans or fruit flies. Unfortunately, a 4000K streetlight is particularly effective at disturbing circadian rhythm.

In humans this has implications for hormone regulation, cell renewal and blood sugar regulation, and so exposure to light at night is linked to an increase in depression, hormone-related cancers and diabetes. In the natural world, artificial light at night has been found to cause disruption at every level: within the cells of diverse creatures from fish to trees, in the physiology and behaviour of individuals and in the complex interactions between species in ecosystems.

The two words 'artificial' and 'natural' are at the heart of what I'm trying to say. Streetlights of any kind are artificial light at night. The light from LED streetlights is especially unnatural, in the wavelengths of light as well as the brightness and the behaviour of that light. Moonlight is natural light at night. Our

moon has been orbiting Earth for a good four and a half billion years, and life on Earth evolved to the changing patterns of its light. Like most things in nature, the moon has a cyclical rhythm – it changes its appearance to us Earthlings as it circles around us. As it moves from a sliver of crescent to a shining full moon, this changes the amount of natural light that shines at night, from a whisper to a full beam. The moon's position moves through the sky each night, appearing to rise and set, as well as through the months and seasons. Whereas (sorry to state the obvious) those streetlights go on shining in exactly the same place on the corner of John's street, with exactly the same bleak intensity.

The moon can seem irrelevant in our over-lit age, just hanging up there in the sky like a nice decoration, eclipsed by our proliferation of photonic bling. We forget that the moon still wields enormous power as it tugs the tides across our planet, and that its light sets nature's clock and moves the calendar on throughout the night.

When we consider the amount of light at night, it isn't just about aiding vision on city streets or the quality of footage from CCTV cameras, but the energy force that programmes the natural world. Life is extraordinarily receptive to subtle changes in colour and intensity of light, throughout the night as well as the day.

I'm mentioning this because other residents complaining to UK councils about too-bright streetlights disturbing their sleep have been advised to purchase blackout blinds and eye masks. Please don't suggest this. Firstly, it's not a pleasant or healthy way to sleep, but also, the local residents subjected to streetlights at night are not all able to purchase blackout blinds. Some are blackbirds and robins, who are fooled by the colour of the light into responding to dawn and wasting precious energy by singing their wee hearts out. Some are insects, drawn into the light. Some are bats, diving and looping in pursuit of insects. Some are migratory birds passing by, drawn off course by the lure of the brightly-lit city. Some are trees, shedding their leaves too late, their perceptions of seasons all out of kilter.

This letter is on behalf of all these residents too, who need no artificial light at all and are now subjected to too bright and too white lighting all night long. I feel compelled speak in defence of not just my friend John but also the moths that silently move through the city gardens, the frogs in the pools and ponds, the otters that slip and swirl in the city's waterways and the owls that hunt from the woodlands. And that's just the crepuscular and nocturnal gang, the streetlights affect the diurnal residents too, of course, by disturbing their sleep.

The moon and its phases matter to Edinburgh's wild residents as they matter to life throughout the world. It's worth understanding this in a global context as the shift to LED street lighting is a worldwide trend, and blue-rich lighting everywhere is making the sky too bright at night. Light pollution, which should actually be called night pollution, is depriving the living world of vital darkness and interfering with the more subtle signals from the moon, thus messing with all systems and beings that respond to moonlight.

Elsewhere, corals in tropical oceans synchronise their mass spawning at full moon, while zooplankton 100 metres deep in the Arctic ocean detect moonlight to trigger their vast migrations to the surface. Some coastal squid even have bioluminescent bacteria inside them so they can mimic the moon's light and camouflage against the moonlit sea. Meanwhile, fireflies prefer the darker nights of a new moon to ensure their mates can see their own light signals.

And us humans? How do we respond to the moon and its light? Its significance to humanity has bestowed it a special place in our mindscape. As long as there have been humans we seem to have been gazing at it, singing to it and investing it with symbol and meaning. Moonlight shines through thousands of years of storytelling, from ancient

myths and legends to folk tales and fables throughout the world and on into contemporary writing, poetry and songs. At different times, places and contexts, it speaks of intuition and guidance, femininity and fertility, mystery and wonder. There's magic in moonlight. There are darker associations too, with werewolves and madness, but also a steady seam of love, lust and enchantment.

I've said 'we' don't notice the moon anymore, but it seems there's a counter current of lunar appreciation swelling gently in this technological age. Moon bathing, like forest bathing, has become a thing. People go deliberately into the night together or alone to drink in the moonlight, expose their skin to it. Apparently, people lead tours and eco-businesses around moon bathing. It sounds daft, and yet... I've felt it, something akin to what they're describing. That night in Coll, and many other nights since, there was a sense of energy flowing and of being recharged. It *felt* like I was absorbing nutrients, something was changing my body chemistry and I was taking in, soaking in, moonlight.

Anyway, back to John's street... I guess what I'm asking is this: that you reappraise your decision to install 4000K streetlights throughout so much of Edinburgh based on a much wider examination of a much bigger picture. It may feel like an expensive mistake to change the street lighting now, but it's

not unprecedented, and will only save trouble in future. Other cities throughout the world have realised they've got it wrong and taken action to rectify it by changing to a warmer, softer light.

I'm not expecting you to take this from me, but please – as Greta Thunberg told US Congress – "listen to the scientists". It's all there, in peer-reviewed papers, being discussed with increasing urgency, from turtles to coastlines to prostate cancer. Continuing with the roll out of 4000K streetlights ignores recommendations from many organisations that have examined the wider evidence on human health and the environmental impact. For example, DarkSky International is an Arizona-based globally active organisation protecting the night. Their recent summary of science explains why blue-rich streetlighting increases light pollution and they recommend no higher than 3000K for outdoor lighting. Following a report on LED safety, the European Union's own procurement guidelines recommend that 'warm white' streetlighting of 2700K and below should be installed in residential areas. In the UK, the All Party Parliamentary Group for Dark Skies recommends following the example of countries such as France in setting standards for the brightness and colour temperature of outdoor light, with legal limits for the amount of blue light.

A 2023 House of Lords inquiry described light at night as a 'hidden pollutant' with 'negative impacts on human health' and repeated this call for tighter regulation. Some wiser countries have already brought in legislation and regulation to restrict light pollution. The streetlights on John's street would not be allowed in France. This is because they've understood that 4000K throughout the night is particularly disruptive to life. That blue-rich note is especially powerful in setting nature's clocks, and the high colour temperature creates more sky glow and so more light pollution.

So, look again at the science, please, and to the reports from those bodies that have examined it thoroughly. But also, I'd urge you to try and tell the difference yourself, experientially. Travel to a wilder, darker place – we are so blessed to still have many within reach in Scotland – and bathe one night in moonlight. Best of all, do this near a loch or coastline or any body of water to amplify the silver. Drink the light into your being. What do you feel? Does it change you? Then return to the city and walk the city streets at night in our new, cold lighting environment. Stand with a loved one under a 4000K streetlight on the corner of a South Edinburgh street, and tell me honestly, would you want to kiss?

Maybe then, only then, you might consider it possible that you have misunderstood the moon.

Deeper Blue – Dark Waters

I stand barefoot on the cold, gleaming sand as the sea retreats with a hiss. There's a moment's pause and I wait with a little shiver of anticipation, wriggling my toes until they sink in a bit. There's no horizon way out there, just the seamless dark of sea and sky, but closer by white horses are rolling in gently, as if coming ashore for the night. The sea turns with a *shoosh* and it's coming back at me, reaching out with frothy fingers, closer and closer. As children we'd run from it, shrieking and giggling with the thrill of the chase. Now I stand my ground and let icy water reach me and swirl around my feet, daring it to come further. It does. As if with an extra push, a sudden surge claims my ankles and comes slapping at my rolled up jeans. The sea has won.

I've never grown out of paddling. The craze these days is wild swimming but, while I love a dip in the summer, paddling is the mainstay of my connection with the sea in all seasons and at all hours. Working from home by the coast here in East Lothian, I'd nip out for a paddle in my lunch hour, and touching water with my toes would reset me somehow. I'd walk the dog in the evening and long into the night, back and forth, barefoot along the edge of the beach, finding my happy place and best thinking

space along the line where the sea meets the land.

Long ago on a faraway island, my diving instructor invited me to join a night dive, luring me with enthralling stories of the underwater darkness. 'It's as close to floating in outer space as you can get!' he said. 'It's disorientating but amazing, you barely know which way is up, and the marine life you see is out of this world...!' Newly-qualified and wary, I declined the offer. I had no desire to be submerged in dark waters, but I have always wanted to be close to them, dipping my feet and feeling the suck and surge of the sea's breath.

On an overnight ferry I sleep in the cabin with the blinds open, watching the sunlight blush and fade and then moonlight appear on the endless surface. On smaller boats I stay up at the front, watching, hoping for the thrilling glow of phosphorescence on the bow wave. I live beside a river now and often I just sit beside it as the sky darkens, noting how fervently it clasps the last of the light to its surface, still shining when the banks are black. Sometimes, when there's no wind and the water is calm, the river holds the moon and rocks it gently.

I've always known that dark waters are beautiful. Now I understand that they are also vital. Darkness is an essential part of any aquatic habitat. In recent years there has been a lot of media and public attention on water pollution, from the obscenity of

sewage and chemicals in our rivers to the travesty of plastic in our oceans. However, though we've been slow to recognise light as a pollutant on land, we have been even more so in and under the water. But this is a realm particularly and profoundly affected by light pollution. Our waters can plead a special case for their need for night, because the aquatic world is exceptionally sensitive to light and darkness and so even subtle changes can be damaging. The balance of light and dark affects the balance of everything, down to microorganisms and bacteria, the hormones in fish, the insects that flit over the surface and the relations between predator and prey within the water. This applies all the way from a garden pond, through lakes and wetlands, rivers and streams, out into the estuaries and deep into the oceans. Darkness matters all the way.

The type of artificial light that we inflict on the aquatic world matters too. Light is complex enough when travelling through the air, but the physics gets an extra twist around water, whether the light is bouncing off its surface or bending beneath. This makes it tricky to study and monitor light as a water pollutant. The ways that we measure light don't necessarily work with its different behaviour when in and around water. There are even further differences between the way light affects life in the freshwater flow of a river and within the salty ocean.

While light is time throughout the natural world, there is an extra dimension in the water. Light is also geography here. The structure of an underwater environment is that natural light decreases the deeper you go. Forms of life have different sensitivities and means of detecting light, depending on the environment that they dwell in or swim through. Ocean habitats are defined by depth and their names refer to the amount of natural light that reaches them. The sun-filled surface waters are the 'euphotic zone' from the Greek meaning 'well-lit', middle-depth is 'disphotic' – away from the light, and deep down is the 'aphotic' – no light.

Light matters even in the smallest bodies of water. When we moved into our current home in Central Scotland, we dug a little garden pond. A friend brought me solar-powered lights to place around it, enthusing that they were 'eco-friendly': 'they just soak up the sun in the day and light the garden through the night!' I didn't have the heart to tell her that was a bit like bringing a vegan a steak pie. My wish for my garden and my pond is for darkness through the night. Everything in it, from the rushes to the frogs, evolved with that. What can you do to create a wildlife-friendly garden, however small? Dig a pond, feed the birds, build a bug hotel, install a hedgehog tunnel … there's plenty guidance around, but it doesn't often suggest to turn off the

lights. Indeed, ponds are often deliberately lit to make an attractive garden feature.

This urge to light garden ponds, oblivious to the impact on aquatic inhabitants, is a microcosm of what we do to waters around the world. We light the lakesides and riversides, bridges that span rivers, and great stretches of coastline. Of course we do. It stems from human passions that resonate deeply with me. Our love of water makes us cluster around the waterside. Long beyond our historic need for water supplies and strategic defence locations, we crowd the water's edge because it feels good to be close to it. There's nowhere I'd rather be. We light up the water mostly inadvertently, through illuminating our surroundings, but sometimes deliberately. Light on water dances, it shimmers and shimmies on the surface, throwing up sparkles and gilded ripples or settling into gleaming calm. Somehow, we love things that play with light in this way, from precious jewels to this even more precious substance.

My friend was only offering me a little taste of all this with lights for the pond, and I ungratefully stuck them on a shelf in the garden shed. Somehow, we need to learn to value the beauty of natural light on dark water: dusk, dawn and moonlight and, if we're lucky enough, even starlight. We need to treasure the experience to the extent that we reign in

our urge to artificially conjure a gleam. We need to wait, and anticipate... when the last glimmer of evening fades from the surface of the lake, let's not fill it with light from the shore but look forward to the first touches of dawn. Let's savour what's real, respect the need for life within the water to sleep in peace, and allow its nocturnal inhabitants to live their lives in the realm of darkness.

Nowhere is the human urge to light water more visible than the coast. Pictures of the world at night taken from the air or from outer space show the bejewelled shapes of our countries and continents picked out in bright sparkling clusters of light. It looks pretty, but it wreaks havoc with coastal ecosystems.

I thought of this a few years ago when we spent the Christmas holidays near my childhood home of Morecambe Bay. Delighting in the lack of street-lights beyond the village, we walked at night, following paths along limestone walls that gleamed gently in the moonlight. On a clear night under a nearly full moon we were astounded by the brightness of the bay. Morecambe Bay is an ever-changing expanse of sand and water, with channels filling and draining in constantly shifting patterns. Wherever there was water, there was light. The woods and fields and rocky coastline were dark or very softly lit. If this was sound, the land was only murmuring or gently singing under its breath when touched by

moonlight, but every ribbon of water was amplified, belting out a full-throated blast of silver. Of course, this is how it was and should be. Coastal life has evolved with moonlit nights that mean dark land and bright water.

Take turtles, one of the best-documented examples of how this works for nature. Sea turtles live most of their lives in the ocean but come to nest on the shore where they were born, ideally laying their eggs on a dark, quiet, tropical, sandy beach. Evolution has offered them the glow of moonlight on the ocean's surface as a reference point to orientate themselves and head to the sea in the direction of the light. All was well until widespread coastal development meant that the tiny, just-hatched turtles were met with a blaze of light from the wrong side of the beach. Even on the brightest moonlit nights the light from streetlights, hotels and cars on the land is now brighter, all of it luring the new hatchlings away from the ocean and into the danger of streets and buildings.

This phenomenon is well-researched and understood, and many coastal areas now switch off the lights for the nesting season or have teams of rescuers to guide hatchlings towards the sea. But coastal light is not just a turtle problem, it's an everything problem. Tiny sand hoppers scatter in random directions instead of using the moon to navigate, which

affects their feeding and reproduction. Dog-whelks change their feeding behaviour. Corals get stressed and cease to reproduce. All of these changes have knock-on affects for other species, sending waves of disruption through the underwater world.

Looking out into the dark horizon, I'd love to think that far out at sea would be one place on the planet that escapes light pollution. But sky glow, the smudgy light that bounces back from the clouds, can reach for miles beyond coastal cities, and the world's megacities are expanding around the coasts. The seas are busy with ships, and their lights have been getting brighter and whiter over the past decades. Squid fisheries in particular use intensely bright lights shone into the water to lure their catch. They're so bright they can be seen from space. Then there are lights from oil and gas installations, and now from offshore windfarms too. The ocean surface is one gigantic light reflector, and so all artificial light from the sky or from boats is compounded.

Light at night lures seabirds towards it, like moths to a candle flame. Sometimes they get 'stuck' in the beams from a lighthouse, circling round and round until they drop from exhaustion. Land birds on migration are pulled in too, as vividly described in *Stargazing*, Peter Hill's account of a 1970s summer spent lighthouse-keeping off the west coast of Scotland. Like 'a nautical remake of Hitchcock's

The Birds', many thousands of migrating birds are drawn in by the lighthouse: "At first the windows seemed their usual two-in-the-morning black. Then I saw the eyes, hundreds of them and more arriving each second, accompanying by bumps and thuds... then I looked upwards. There were thousands and thousands of birds, circling in the beam of the turning light. Even from the ground I could tell they were of different types, specks of wren and blobs of thrush and redwing..."

The lighthouse keepers tell him that it happens twice a year, 'every window alive with birds and the whole tower filled with the sound of their beaks tapping against the glass', the ground 'bubbling with a frothy carpet of feathers' and the next day the flat roofs of the outhouses 'carpeted with dead birds'.[15]

Similarly, seabirds are drawn to the lights of ships, sometimes crashing into them or landing on their decks. Some nocturnal species, such as shearwaters and petrels, are cliff-nesters and can't take off from a flat surface so they flounder and die on the ship's deck.

Whatever light falls on the water's surface affects everything below it, any changes cascading down into the depths through the movements of creatures and nutrients and the many complex interactions between predator and prey. It's all connected through one intricate ocean ecosystem.

The biggest migration on the planet in terms of sheer mass is the vertical migration of billions of plankton, travelling up and down through the water every day and night. Phytoplankton – tiny forms of plant life – flourish near the surface where plentiful sunlight fuels their photosynthesis. Zooplankton – tiny forms of animal life, including the early-life stages of crustaceans and fish – dwell in the darker waters below and travel up at night to feed on phytoplankton and smaller zooplankton. They do this in darkness to be safer from predators that dwell near the surface. When the sun comes up, they scurry back down to the safety of the darker deep.

Scientists studying this phenomenon wondered what happens in Arctic winter when there is no sunlight – do plankton still move between the depths and the surface, and would it just be random chance when they did so? They found that moonlight was the trigger that drove this colossal-scale migration. It wasn't 'dark' by the plankton's reckoning, as they were more sensitive to light than anyone had realised and could detect moonlight on the ocean surface from hundreds of metres deep. The scientists also realised that this level of light-sensitivity rendered earlier studies invalid, as the light from their own research platforms affected the behaviour of their tiny subjects – zooplankton avoided the artificially lit surface while they were working.

That plankton are finely tuned to such subtle light levels has huge implications. Plankton matter. They are the basis of life in the ocean, as food for everything from fish to whales. Their photosynthesis creates oxygen, for the ocean and for us all. Upsetting the balance of phytoplankton and zooplankton can result in algal blooms, creating toxins and affecting the oxygen level in the water. They also carry a conveyer belt of nutrients, and millions of tonnes of carbon, from the surface to the depths.

The deepest ocean is one of the few places on Earth where there is absolute darkness. And in this inky blackness, what does life do? It makes its own light. Most creatures of the deep create light, either by chemical reactions in their own organs or by teaming up with bioluminescent bacteria. Here, light is not just time and geography but also language, the main means of communication used to lure prey, deceive predators, hide, attack, alarm and seduce.

US oceanographer Edith Widder has been exploring this language of light throughout her working life, travelling by submarine where few of us would dare go and bringing back enchanting footage of the extraordinary light shows of the deep. First there's darkness, she shows, and then strange blobs appear in blues and soft greens, lights in rings, circling and scattering, swirling and pulsing with blue sparks. Sea gooseberries drift by, pulsing floating

oval-shapes with rainbows rippling and running along their translucent bodies. It is, as my diving instructor said long ago, out of this world.

Would I want to go down there and see it for myself? The dark sea looks simultaneously appealing and daunting, surging with mystery. No, I'll stick to my paddling, my feet no longer feeling the cold. But I'm enchanted and intrigued as by a journey to the moon or outer space. What's out there? What's in there?

Whale expert and science writer Erich Hoyt used to live close by here in North Berwick, further along the beach. We would meet sometimes and swap whale stories, I'd tell about counting minke whales in the Hebrides and he'd tell his latest adventures studying orca off the Kamchatka Peninsula. His book *Creatures of the Deep* took me on an exploration through the depths of the underwater world. I've been familiar with Erich's work since my school days when I found his seminal study of orcas in the village library. His account of living beside, meeting and playing music to the whales around Vancouver Island reads like a novel, so vivid that some scenes stayed in my head and feel like my own memories. I know, through it, how it feels to have a gleaming black orca surface beside a small boat. To row in the sea at night when the water is bright with phosphorescent plankton, and hear the breath of whales nearby. I feel I

know the misty coastline of British Columbia though I've never been there, so Erich is good company to descend into the outer space of deep ocean with.

In *Creatures of the Deep*, Erich explains that most creatures in mid and deep ocean use bioluminescence in one way or another, leading to special adaptations in the eyes that perceive the lights. He introduces a colourful cast: vampire squid that shoot bioluminescent clouds, viperfish with light organs along their bodies and dragonfish with two sets of lighting on their heads – one that only other dragonfish can detect. Using red light in a world of blue and green is like having their own radio frequency.[16]

What do we do to this language of light when we pollute the ocean with artificial light? What conversations and interactions do we interrupt? What are the consequences of this disturbance?

Back on the beach I watch where I tread while night paddling, glancing down for the sharp edges of stones or shells protruding from the sand. There's a faint gleam wobbling ahead and I wonder if it's a stranded jellyfish. Peering closer, I see that it's a bit of soft plastic caught around a stone and anchored in the sand. I pick it up and turn to head for home, hoping that's one less piece of plastic floating in the ocean. There are rafts of plastic many miles wide out there, and the bits you can see aren't even half of the problem. They do 'nurdle hunting' on this

beach – trying to pick up tiny pellets of plastic washed ashore. These are the raw materials of the plastic industry and trillions of them are awash in the world's oceans, breaking down into ever-smaller particles. The purpose of nurdle hunting is just to track where they're washing ashore and to raise awareness; there are simply too many for a nurdle hunt make any impact on the quantity.

My heart is a swirl as I climb the slope of thicker, drier sand, still carrying my shoes with my fingers looped into the heels. I'm exhilarated from the touch of cold water, the scent of the night sea and the taste of salt on my lips but I'm crushed under the weight of the troubles we've inflicted on our oceans. There are even microplastics in the clouds now, as well as 'persistent' chemicals (named so because they stick around forever, building through the food chain in the bodies of marine animals). Orcas in Scottish waters have been found with high concentrations, thirty times the toxic threshold, of persistent chemicals that were banned decades ago. climate change is causing chaos with every aspect of ocean ecology. Artificial light is one more pollutant exacerbating the effects of all the others. And it's the one that's most easily solved. It's not persistent. Darkness can be restored with the flick of a switch. Given all that the watery world is going through, could we just switch off the lights?

I Love You, Cam
and Declare Your Right to Night

Soft summer rain was falling on a midsummer evening as we stood in a defiant circle near the riverbank. We gathered here, with a prelude of procession, painting, poetry and song, to declare the Rights of the River Cam. These rights had been adapted from a Global Declaration of River Rights, printed as a ceremonial document and we grasped our copies and read them out loud like a chant. It was tricky to get the timing right with a large circle speaking in unison, yet the words gained power as we pronounced them together. We weren't just reading, we were declaring – a sense of solemnity and gravitas in the damp air all around and between us. Nearby, willows dipped their long arms into the Cam, and the rain made tiny dimples on the water's surface.

The idea of a river having rights has been gaining traction throughout the world. We heard of rivers in Bangladesh and New Zealand having their legal status recognised, as part of a growing global movement asserting the rights of nature. The rights we were declaring were not legally binding, but a statement of intention of what should be. A lawyer gave a speech, explaining the logistics of these claims; if we wait for courts or parliament we could be

waiting a long time, he said. We need to act now, as if these rights were real, and so they will become so. The difference between the declaration having no effect or a massive effect depended on what we did next. He exhorted us all to go further to express our commitment as guardians of the river: make a noise, keep campaigning, write a love letter to the Cam.

This made me smile, partly in surprise at a lawyer instructing anyone to compose a love letter to anything, but also in a startling recognition. I had only recently realised that I had been falling in love with the Cam.

It certainly wasn't love at first sight. See, I'd landed in Cambridge from Scotland, where rivers rush and race and surge through glens and cascade down rocky drops and hurl gleaming salmon from their raging froth. I've watched in awe as rivers casually carry tree trunks, tossing them around playfully as they hurtle along. I've paddled in rocky coves, feeling the tug of a river's momentum on my bare legs. I've watched otters slip into their swirls, disappearing with a flick of a tapered tail. So, I came to have certain expectations of a river as a force of energy, full of character and thrillingly alive.

'Call that a river?' I'd thought, when one of life's freak waves lifted me from my home in Scotland and put me down right beside the Cam. It was pretty enough, edged with coloured houseboats

and fringed with willows, but seemed as tame as a suburban canal. If there was aliveness, it came from the humans that moved along it from the first hint of daylight: running, walking, cycling, buggy-pushing and, of course, rowing, rowing, rowing. The rhythmic *chunk, heuch* of oars and the shouts of the coxswains were the soundtrack to those first bewildered weeks as I watched the river from my new office window. It seemed the people here moved constantly and full of activity, but the river didn't do much at all.

'Come closer,' said Cam, and so I edged toward the riverbank and sat watching the patterns of sunlight shimmering and wriggling on the surface. I looked into the reflections of the willows and deeper, below, to the dark shapes of small fish flickering through the shallows. A moorhen crossed the river, bobbing its head back and forward like an Egyptian dancer, stepping out with astonishingly large feet. And there! What's that? A rat? No, too fluffy, so buoyant on the surface. A water vole moving along the reedy river's edge.

Other river sounds became familiar, along with the oars of the rowers. I'd lie in bed listening to the clop, clop, clop of swans' wingbeats; the first time, half asleep, I'd thought of horses on the riverbank. One morning in May, a few homesick months into the move, I'd woken to a sound that was strange and

familiar all at once. I was drifting in and out of sleep, wondering how such a harsh sound could evoke such sweet memories. It was grating and rasping and yet it filled my sleepy mindscape with Scottish islands and boat trips, pink thrift against blue water, sea cliffs and big skies. Was I dreaming? I reached over and tugged at the curtains. An elegant white bird was dancing over the Cam, circling, hovering and flickering in the air, then suddenly plunging, gannet-style, into the water. Terns! What are they doing here, so far from the sea? They'd come upstream to breed, come to remind me that we're not so far from the sea, that this is a river of course, a real river that flows on to the sea, connecting this city to the open ocean, as water connects the whole world.

In the years that followed, the first tern on the river would herald the turning seasons, and I'd look forward in anticipation. I greeted that first sighting with significance and joy, the way people do with swallows. The grating cries of terns spoke to me of summer, of sea, of connection.

'Come in', said Cam, as spring turned to summer. I stepped, shrieking, off the steps and out of my depth. I gasped as Cam rushed around me, the sting of cold on my arms, my belly, my breasts. I let out a yelp of exhilaration as I reached out and swam, and the cold shock eased to cool silk, flowing all around me. So this river does move! I could feel the

gentle tug of Cam's current, it carried me one way and I could feel an extra push as I swam against it. I flowed with it a while, encased in a world of green. High above was an arch of branches and the light was filtered through silver-green leaves. All around and below me, green water moved over deep green plants that reached and stroked my feet, making me start and flinch away. The green world was emblazoned with huge, bright turquoise dragonflies, shining as if lit from within.

Then came Covid, with so many people everywhere cooped up and deprived of green. I felt almost guilty at my good fortune to be locked down so close to Cam. The sounds changed then, the tug of oars ceased and the birdlife flourished. In that uncanny limbo, as if the music stopped with people frozen in time wherever they happened to be and whoever they happened to be with, Cam was vibrant with new life. The moorhens were followed across the river by the strangest wee creatures: tiny black fluffballs with baldy red heads and a paint-dip of yellow on their beaks. And the size of those feet! The coots' chicks were similar, with a straggle of yellow fluff around their necks. We watched swans guarding their large, messy nests, rejoiced when the fluffy grey cygnets appeared, sometimes piggy backing on their sleek white parents, sometimes gliding beside and between them. We became engrossed

in swan politics throughout that strange spring, intrigued by the tensions and territories within and between families, the posturing and bickering, the flapping of huge wings in warning.

I had a big birthday during that time, for which I had long planned a ceilidh – dreaming of dancing in a great long Orcadian 'strip the willow' and of knowing every smiling face that spun around me as I hurtled down the line. It was not to be. Who knew when we would ever dance again? My big birthday brought not a ceilidh but a kayak, and a new dimension to my relationship with the river. I felt sheer joy surging through me every time I stepped into my blue kayak and pushed off from the bank. Cam held me, carried me so easily, kept me company so gently. I wasn't interested in going anywhere fast; I just loved to float and pootle around, watching the birdlife, peering into the river, drifting along looking for the neat, round water vole burrows tucked under the vegetation on the banks.

I would sit in quiet creeks, barely rocking, just lilting, watching Cam rippling, often waiting, hoping, for a shining glimpse of kingfisher. I was closer to everything in the kayak. I loved the low view of the water, the way the birds didn't startle as I slipped past them. I encountered them differently from this level. I could see which water vole holes were active, the smooth paths where they slid into the river. I

paddled further, up towards the lock, beguiled by elegant passers by – a pair of great-crested grebes following each other downstream.

I think it was around that time that I started talking to the river. Just a casual 'Hi Cam' as I slipped into the kayak and dipped my oar, loving the texture of the water as I pulled at it. I'd let my hand drift, touching Cam. I'd stop on the school run and just take in the scent – the sweet, fresh note of river in the warm air.

'Hello, Cam,' I'd say as I passed with a smile of acknowledgement.

And with love came concern, and worry, the way it does with everyone and everything that I love. I began to learn how my beloved river, like so many rivers throughout the land and throughout the world, was in trouble. Some of Cam's woes were shared by many rivers: pollution from sewage, from litter, from chemicals – especially the runoff into the water from intensive agriculture. Some were more specific to Cam's own context, such as the results of many years of over-extraction. Clear, pristine water, naturally filtered, fills the special habitat of chalk streams that flow into the river and too much of this was being taken. Cam was running low on the very essence of river itself: water.

It felt good, then, and strangely powerful, to voice these concerns out loud and with others. To

stand in a circle together and declare Cam's rights to protection from these and so many threats. Our voices threaded together on the riverbank in the rain, forming something of substance, like an incantation, like a blessing. What even is a right? It's a claim. We staked Cam's claim to water itself, to flowing freely, to protection from over-extraction, to being free from pollution, to maintaining connection with other rivers, and to native biodiversity and restoration.

What more could a river want? There was something we missed, something so fundamental and essential that it is often forgotten: darkness. This living, moving entity, this body of water, has a right to a rhythm. Dawn, day, dusk, night – the pattern of light and darkness since the beginning of time.

Rivers are particularly susceptible to the loss of darkness and the problems of artificial light at night. Compared to other bodies of water, such as freshwater lakes, the ratio of bank to water means that riverside lighting can affect most of the water. Because we like to dwell and play and eat and drink by the riverside, we light it disproportionately. Like the coastline, you can see the world's rivers in images from space, defined by the way lights cluster around the estuaries and then shining bands of light snake inland.

Recent studies have shown that rivers need darkness to maintain healthy ecosystems in and around them for the plants, fish and especially the insects, whether above, below or at the surface. Sixty per cent of animals in freshwater are insects, with about 100,000 known species. Many of these have evolved to orientate themselves by the reflections of natural light at the water's surface and so are vulnerable to excess and unnatural light. Most nocturnal insects, including those that spend much of their life cycle as larvae in the water, have incredibly efficient sensors so that they can detect even low levels of light. Some can even use starlight for orientation.

The UK charity Buglife, which fights for insects, has been a leading campaigner against light pollution and among the first and few environmental organisations to highlight this issue as a major concern, saying, 'A single light on a tree or river could prevent generations of bugs from emerging, with drastic knock-on consequences for ecosystems'.

As well as bankside lighting, river-creatures have to contend with light from bridges abruptly interrupting the flow below. When bridges are lit at night, the shine slices across the river, forming a barrier for migrating fish such as salmon and eel on their long journeys. In one study of an illuminated bridge, flying nocturnal mayflies were attracted by the streetlights and also 'led astray' by the reflected

light from the asphalt on the bridge, which they perceived as a sheet of water. The ecologists showed how both direct and reflected light lures large numbers of insects off course.

All these studies show so many changes to different life forms when a river is deprived of darkness at night. To take just a few examples, nocturnal spiders on the riverbank begin to forage by day instead and salmon fry take longer to disperse. Each change then ripples through the river, altering who encounters what and when, disrupting the balance between the hunter and the hunted and the rhythms of river life.

Cambridge is not so bad as cities go. I used to enjoy the riverbank at dusk, watching the bats flickering over the water. Not bad, but still there were security lights on the industrial estate that pierced the night for miles around. I would raise my hand to shield my eyes from the other side of the river. And on football nights, the floodlights from the stadium would shine not just on the pitch but everything around. Then a new, small housing development was built just beyond a new footbridge with absurdly bright outdoor lighting that blazed into the riverbank path and spilled onto the water. It stole the dusk, and the dark, from my evening walks, from the bats and the midges and the owls and, of course, from the river itself. I stopped walking that way to avoid the lights, but the rest of

the inhabitants of river and riverbank didn't have that choice, and nor did Cam.

I feel Cam's need for night, and my wish and my hope is that we can tone down the light and restore the darkness.

So here it is, my letter to you, Cam. I love you, my precious river, and I declare your right to night.

This guy ALAN
– and introducing DAN

In dark sky discourse, when astronomers and ecologists and lighting designers get together, there is now a common use of the acronym 'ALAN' for Artificial Light at Night. You hear an awful lot about this guy ALAN – his astonishing growth and extensive reach, affecting so many different aspects of life and the living systems on our planet.

I often imagine ALAN as a large, smug and swaggering thug, oblivious to the damage he's doing and the havoc he is now wreaking as he strides across the world.

Sometimes, when I stand on my front doorstop at night and look out over the absurdly over-lit landscape, I hate him. He's so full of himself, and so loud: screaming from the football stadium, screeching down the roads, blasting from closed buildings and smudging the sky.

I've been a bit obsessed with ALAN for years now. I'm appalled by his behaviour in his current state and constantly seeking to warn others about him. And yet, if the truth has to be told, I wouldn't be without him. Would I even go out without him? Say it quietly: I love him still. Of course I want the lights on at home. I want ALAN in the park when I walk the dog on a winter's evening.

ALAN is humanity's creation and one of our greatest treasures, transforming human society and capacity. Life as we know it needs ALAN and would be inconceivable without him. He wasn't born bad, we just made him that way. Frankenstein-like, our precious creation grew too big, then began threaten us and our world. Somehow, we need to calm him down, quieten him to a tolerable level.

I've been wrestling with all this and looking for a way forward. It got me thinking about ALAN's older, wiser, acronym-brother, who I call 'DAN'. DAN is Darkness At Night. In our society's excitement and pride about the showy, glitzy ALAN, it seems we forgot about the quiet, deep guy that is DAN.

It's DAN that can help to restore so much of what has been damaged and broken by ALAN's recent excesses. DAN can soothe over-wrought nervous systems, ease the insomnia, offer a balm for fractured and strained mental health. Hanging out with DAN could put us back together again, get the right chemical signals coursing through our bodies. DAN can lull us to deeper sleep and healing.

It seems to me that valuing DAN is the only way to keep ALAN in check. The way forward for our daily lives, for our towns and cities, for humanity, is to find a balance between these two brothers – recognising and appreciating the benefits of ALAN but acknowledging the essential presence of DAN.

This guy ALAN

Here's the irony. Most of my life I've been afraid of DAN. As a child I'd have ALAN with me always, right through the night to make sure I would never be alone with DAN. Even as I got older, I'd take the possibility of ALAN with me always. His potential presence through the torch in my pocket would be enough to reassure.

When I came to study in Edinburgh I found a flat on a busy road with a pedestrian crossing beeping below and a streetlight attached to the wall right outside one of the bedroom windows. I went with friends to view the flat, bagsied that room and sighed with sheer relief. The orange glow of the streetlight shone through the thin curtains and kept DAN away from dusk until dawn. It was wonderful. DAN didn't exist in this new life, unlike back home in the village where nights were deep and dark.

Now I'm constantly longing for DAN. I'd travel far just for one night together. What changed? Artificial light itself changed, from the softer, warmer hues of my childhood, to something increasingly harsh, glaring blue and intense. Learning about that change took me on a strange journey. It had all sorts of twists and turns but ultimately this most important outcome: I met DAN. I found he was ok after all. Actually, he was amazing. After fearing him so long, I began to welcome

him as blessed relief, to seek him out and prioritise time together.

Like many of my species, I'd got it so wrong. I thought we needed ALAN always to protect us from DAN. Now we urgently need DAN to save us and the rest of the living world from ALAN.

Yes, the rest of the living world, by which, in this instance, I mean the rest of life except us humans. That's where we differ. The natural world doesn't need ALAN. Full stop. Just as it doesn't need traffic, or buildings, or tarmac. ALAN is part of us and what we inflict. He is bad news, and his presence anywhere is pollution. Our best hope is to contain ALAN and allow space for DAN. If we let him spread and tread softly into the wild places, DAN will ensure safe passage for bats to fly and hunt, for eels to slither along their long migration journeys. He'll help pollinators to pollinate and sing great trees to sleep. Only DAN can reset the clock throughout the living world, restore the connections and recover the calm.

I'm not taking sides between these brothers. I know I need them both nowadays. If I do seem unbalanced in favour of DAN, it is to redress a relationship that's got way out of kilter. Our neighbours in the living world need DAN so much that we have to give him more space in this planet that we dominate. Because the truth of it is that DAN

This guy ALAN

is necessary for life on Earth, and ALAN is not. ALAN is ours alone. So if we keep DAN close to us and give him space to flourish, we can nourish all of creation as it is meant to be.

Twinkle Twinkle Little Satellite

Have you ever wished upon a star? I have – especially on shooting stars, with a shriek of surprise and joy as I look up at the night sky and suddenly something zips across the darkness, then is gone. Like a glimpse of a kingfisher on the river, it's a moment of brilliance that's over before you can say 'Oh!' and gone long before you can jolt into absurdly inadequate attempts to point it out: 'Look!', 'There!', 'It was there…'

An astronomer friend broke it to me gently one day: they're not actually stars. They're specks of rock – or meteors – falling through space, hitting the Earth's atmosphere at many thousands of miles per hour and zooming across the sky as they burn up. They're not that rare, either; this happens many times each night. However, being at the right time and place, in the right weather conditions, and attentive enough to spot one, is a special occasion indeed. So I wish on them still.

As a child I would lie and look for shooting stars when camping on clear nights, scanning the sky the way I'd hunt so thoroughly for a four-leaf clover in a meadow. I was excited by the possibility of seeing something deemed significant, and always hungry for wishes. Seeing more than one shooting star in a night felt like implausible riches.

But that was then. Nowadays, if you lie in a field and look up – especially soon after dusk – you're likely to see many lights moving, long trains of them marching steadily across the arc of the heavens. They're not stars, nor any natural phenomena, but a new spectre in space: 'mega-constellations' of low orbit satellites beaming high-speed internet connection to the Earthlings below.

Man-made satellites have been in orbit around Earth since the late 1950s in relatively small numbers. Everything changed in 2019 when a new space race began, launching a new era in our use of the skies. Elon Musk's company Space X announced the launch of 60 new satellites in its 'Starlink' project. Other companies followed suit, scrabbling to offer 5G from space. By 2023 there were about 9000 active satellites. Now DarkSky International reports that there are about 100,000 new satellites planned from a number of commercial space companies.

Does this matter? Isn't there space enough out there in space itself? At first it was only astronomers that complained, aghast at the prospect of this interference with the skyscape and with their work. The proliferation of low orbit satellites messes with astronomy on a number of levels. Firstly, they clutter the sky. This affects the visual and aesthetic experience for anyone looking upwards, whether

star-gazers or professional scientists. Things that move draw your eye, like the way it's hard not to look at a television when it's on in the corner of a room. Moving lights are an irritant and a distraction from the peace and fascination of the still night, like a noise in the silence. On a more scientific level, the trains of satellites interfere with visual observations and radio frequencies, distorting data and leaving streaks across the images produced by specialist telescopes and cameras.

Gradually, awareness radiated out into wider environmental interest groups, with the realisation that rapidly growing numbers of satellites will impact far more than astronomy. Again there are many levels and strands of concern; there's the energy required to get so many satellites into space, and the carbon cost of that; there are questions over the effects of blasting 5G radiation to every corner of the planet; and there's litter. Space junk is rapidly accumulating up in the sky, with bits and pieces of man-made debris orbiting around and falling from space, increasing the possibility of collisions.

Light pollution all over Earth can be seen from space, altering the landscape and outlining the coasts. Now, it works both ways. If we look from Earth into space, we can see artificial light there, too. Initially satellites weren't viewed as pollution,

or even artificial light at night, as they are 'only' reflecting the light of the sun to the dark part of the Earth. Now it's understood that they are a new and significant form of light pollution, adding bright, moving, unnatural light to the sky and changing the patterns of natural light. They also increase the brightness of the sky by as much as ten per cent, even when you can't see them directly. Though Space X and others have been working hard with astronomers to find ways to reduce the brightness and mitigate the impact, it seems inevitable that the sky will get brighter as the number of satellites continues to increase. And increase they will, to hundreds of thousands…

Can't anyone slow, if not stop, this surge to fill the skies? With little or no regulation, and a long, dragging lag between the speed of change in technology and change in the law, it seems like there's a rush to get into orbit before any rules can come into place. The lack of restrictions opens philosophical questions: whose is the space we call inner or outer space? Who can or should regulate activity up there? How does this impact the ancient practices of indigenous people and their cultural relationship with the sky? There are calls to acknowledge space as an ancestral global commons, and to re-classify outer space as an ecosystem, subject to environmental laws and protection.

It's an environmental issue on Earth, too. We are not the only astronomers in the animal kingdom. A diverse cast of creatures look to the heavens for orientation and behavioural cues, and know and recognise the patterns and rhythms of tiny, faraway lights – sometimes to an astonishing extent. Many species of migratory birds use the stars to help them navigate, alongside and together with cues from the sun and the Earth's magnetic field. How can they do this when the position of the stars changes through the night? In the 1960s scientists in the US created a planetarium for indigo buntings – vibrant-coloured, sparrow-sized songbirds, which migrate at night. They switched off different constellations to see which made a difference to the birds' orientation and flight direction. They discovered that the birds use a fixed point, such as the North Star, as a point of axis to recognise constellations and monitor changes to the sky. This is not innate to the species, but learned by observing the stars.

Researchers in Germany built an aquatic planetarium and found that seals could see the brightest stars, recognise a 'lode star' or guiding star, and use this to orientate themselves. This may help to understand the mysteries of marine mammal migration. Scientists are investigating whether humpback whales use the moon and stars as navigational aids on their precise paths across thousands of miles of open ocean.

Dung beetles in South Africa don't have eyes that can see individual stars, but they too look up for direction and can use the streak of the Milky Way to orientate themselves as they roll their giant balls of dung in a straight line, away from competitors.

These are just a few of the better-known examples of celestial navigation among other species. It's an area of animal perception we're still discovering so much about and it leads inevitably to the urgent question: as ever more satellites clutter and confuse the night sky, how will these 'artificial stars' affect the Earth's other astronomers?

Is the presence of so many satellites a necessary evil in the modern age to ensure equality of internet access? The satellite companies, of which Space X is the largest, argue that they will offer low-cost, high-speed internet around the world, helping to end the digital divide between urban and rural areas, and between nations. Others say it's the privatisation of space, the colonisation of the cosmos, described in *The New York Times* as 'Musk's extreme, extraterrestrial capitalism'.

From Edinburgh's Royal Observatory, Andy Lawrence, the Regius Professor of Astronomy, was moved to write a polemic entitled *Losing the Sky*, about the prospect of just that. Once the scheme is complete, he says, there will be more satellites than stars. He argues that the requirement of such

high-speed internet access is mostly driven by gaming and financial speculation, and that there are other ways of bringing low-cost internet to wider areas."The satellite problem, and the longer standing problem of light pollution, are part of our ongoing environmental catastrophe. Losing the sky is just the last damned straw. This is why everybody should care."

When I look up into the night sky and see satellites moving across it, I'm filled with an overwhelming sense of foreboding. I resent their presence, littering the sky and drawing my eyes away from the stars, and dread their proliferation. A sentence from DarkSky International's latest report lingers in my mind: "By the late 2020s, hundreds of satellites may be visible to the unaided eye at any moment from a given location". Hundreds? And so soon – that's before my daughter is even grown up. Will we lose the sky so quickly? Professor Lawrence's words echo, too: 'There will be more satellites than stars...'" What will our experience of the night sky be like when this happens? And what will become of all those wasted wishes?

In a Dark Sky Place

"But *why*? I just don't *get* it!" my friend grumbles. "There are dark skies throughout Scotland, so how can you say 'this is a Dark Sky Place and not that, this island and not the next, this glen rather than that woodland' – what's it all about?"

I'd suggested a weekend at one of Scotland's designated Dark Sky Places. We've got a fair few to choose from now. First there was Galloway Forest Park, then the Inner Hebridean island of Coll. The southern village of Moffat followed, then Tomintoul and Glenlivet Dark Sky Park in the heart of the Cairngorm Mountains. More recently, North Ronaldsay, the most northern island of the Orkney archipelago, became a designated dark sky community. And now the Isle of Rum is Scotland's first International Dark Sky Sanctuary.

It's true, I concede, that these are not necessarily the places with the darkest skies, and they may not be darker than neighbouring areas. And yes, we could drive north, south, east or west from here to a remote spot and be sure to find some glorious sky-gazing on a clear night. But the sky is only half the story. To become a designated dark sky area requires not 'an exceptional or distinguished quality of starry nights', but local people committed to

keeping it that way. Where there is a dark sky designation, there's also a shared human commitment to protecting and celebrating the darkness.

This was the additional lure for me. I wanted to meet the people who cared enough to set this process in motion and sustain it, measuring the sky quality, building a team, liaising with local businesses and explaining to other residents why it matters. In a dark sky place, there's a heightened awareness and understanding of issues like the angles, intensity and brightness of outdoor lighting. Street lighting may be dimmed or directed to the ground instead of the sky and lights on public buildings will be softened. Above all, there's a questioning: how much artificial light at night do we actually need?

Dark Sky status is awarded by the Arizona-based, globally active organisation DarkSky International. Initiated by astronomers, it has now become a major global force with groups and chapters in many countries leading the counter-current against an over-lit world. Dark sky places are essentially reserves. Like anything endangered, darkness needs ring-fenced areas for its protection. There are now more than 200 certified places in more than twenty countries, including parks, sanctuaries, reserves, islands and communities, and a vibrant network of individuals working as dark sky defenders around the world. The Pacific Island of Niue

became the first ever Dark Sky Nation in 2020, and New Zealand is on a mission to follow suit.

Like any reserve, the very concept has its limitations, as the natural world doesn't observe our designated or legislated boundaries. Whales don't stay within marine protected areas, nor birds within their sanctuaries. Pollution in the sea and sky can't be kept out of these areas. The sky encompasses everything and has no boundaries. Skyglow smudges miles beyond its original source and the protected status of an area on Earth won't alter the course of hundreds of thousands of low-orbit satellites. And yet, like any reserve, it's a good starting place and a valuable intention. Crucially, it's an acknowledgement of something of value, something that's appreciated, noticed and worth concerted action to protect and preserve.

From this starting place there's an upward spiral, a location now on the map as having something special in its sky. There's also a connection to other dark sky places and people around the world. This stimulates interest among local residents and draws visitors in, boosting tourism and increasing the perceived value of darkness. 'Astro-tourism' has now become a 'thing' and interest is surging around the world. This is not just for spectacular and famous phenomenon like trips to Norway to see the northern lights, nor for the fanciest telescopes

and astronomical facilities. There has also been a quiet resurgence – bolstered by dark sky places – of demand for a calm villages with no streetlights; towns with soft lighting so you can visit the local pub and still stargaze on your way home; and local hotels with a star chart, a telescope, or a pair of binoculars on the windowsill. In our garish, glaring, too-bright society, darkness itself has a growing appeal and commercial value.

We decide on the Cairngorms. When we tell friends where we're heading, they're full of advice. It seems everyone has something to recommend, a favourite spot or cherished memory of the walk to Loch Mallachie, the ospreys at Loch Garten or the crested tits in the woodlands. No one mentions what for me is the main attraction: the darkness. I'm going to the Cairngorms to lie at night with the campervan window open and feast on the sky, to carry sleepy children out in their sleeping bags and show them a night full of stars and, when the night is cloudy, to relax at last into the balm of deep darkness. I can't wait.

I meet local astronomer Sam Robinson at the visitor centre in Tomintoul, the highest village in the Highlands, to learn more about how a remote area within the Cairngorms became an International Dark Sky Park in 2018. He explains how the process took four years, with plenty of challenges and

triumphs along the way. Initially they had hoped that the whole of the Cairngorms National Park could become a dark sky place. As the largest national park in the UK, it stretches over 4,500 square kilometres of wild, upland terrain with mountains reaching and golden eagles soaring into those precious skies. But the Cairngorms also crosses five different local authorities with responsibility for public lighting and planning, so the logistics and cost of organising and coordinating the process would be astronomical. They settled instead for a chosen area of 244 km² with a natural boundary of hills offering protection from light pollution of nearby towns. A team came together comprised of Moray Council, the Cairngorms National Park Authority, the Cairngorms Astronomy Group and the main landowner of the Glenlivet Estate. Working together over the years, they gathered the necessary information, measured the sky quality and put a programme of lighting improvements in place to ensure the skies would be dark enough to qualify.

Some inspired examples included a 'lighting amnesty' in the village square, where local householders could pick up 'dark sky friendly' outdoor lighting for free by showing a photo of their non-compliant fixtures or fittings. Rather than making demands, the team took their softer lighting around local farms and offered to install it for free.

Education and awareness is a vital part of the process and the Dark Sky Park team have continued to build a lively programme of events throughout the year. As well as a permanent exhibition at the visitor's centre and a website with stargazing charts and guidance, there are monthly 'observing evenings' with night walks, moon viewings, star gazing, stories and special gatherings for meteor showers. Accommodation businesses in the area are kitted out with 'dark sky packs', including head torches with red lights, maps of dark sky sites and information about the stars.

With a nice note of irony, one stumbling block along the route to dark sky accreditation was the brightness of the winter skies. Darkness is described using the Bortle Scale, a nine-level numeric scale that measures the brightness of the night sky and the stars to the naked eye. It's an inexact science as our eyes differ in terms of how much we can see. However, these measurements must be taken over a period of time and throughout different seasons. The designated area, nestling within the Cairngorms, initially didn't meet the requirements to qualify as a dark sky place because the sky was too bright. This wasn't from light pollution but the sheer amount of natural light at night: the northern lights, the moon and the Milky Way reflecting on the frequent winter snow. They had to adapt the way they measured darkness to

take the conditions of this northern latitude and high altitude into account.

It made me wonder, not for the first time, if 'dark skies' is something of a misnomer. For, of course, dark skies are so often not dark at all but a constant and astonishing light show of celestial activity. Maybe we should call them real skies, pure skies, true skies? They are skies as skies should be: pristine and unpolluted, full of beauty and wonder.

Hope, in the Form
of Dark Sky Stories

It's my first visit to this south-west corner of Scotland and I'm curious and expectant to see a new landscape of rolling hills and big coastal skies. But as we wind along the road I can't see a thing beyond the windscreen. The wipers can barely keep pace as the rain is battering down and slooshing on the glass. Hitching a lift from Edinburgh with another participant, we're heading to Europe's first Dark Sky Places Conference, appropriately set in the UK's first Dark Sky Park within Dumfries and Galloway. We're far enough away from Scotland's cities here for the tourist board to boast of real dark and 'breath-taking and rare starry skies. I feel for the conference organisers who have drawn people from as far afield as New Zealand, Chile and Israel to share their stories under the promise of pristine night, hoping to put this area on the global map as a stargazing destination. It rains and rains and rains as we follow a long, wooded drive to arrive at the conference venue, a hotel where the spacious lawns are fast becoming soggy pools. We put our coats over our heads and dash inside.

Once indoors I step into a vibrant world, an upbeat swirl of stargazing, science, art and tourism.

There's a buzz about the conversation everywhere, in the conference rooms and down the corridors. It's hard to select from a tantalising menu of talks and presentations. After much deliberation I choose a double act of a marine biologist and neuroscientist describing the impacts of too much light on human health and the natural world. They tell us how the 'broken clock' of light and dark is disrupting all forms of life. Then, a cultural geographer revels in his title 'Delicious darkness and the virtues of gloom', exploring the theme from a dark restaurant in London where you can't see what you're eating, to the thrills of a ghost train in New Zealand. A psychotherapist and cultural astronomer reports back from fieldwork in the Channel Island of Sark, where there are no cars or streetlights and children grow up without a fear of the dark. She explains how dazzling night skies are just part of normal life as an evening's shared entertainment, and happenings in the heavens are joyful community events. At dinner, my table includes an astronomer who travels with a mobile planetarium teaching kids about the night sky. He talks with the shining enthusiasm of someone doing work they truly love. Scotland's then Astronomer Royal, the late John Campbell Brown, exudes warmth and humour as he performs some nifty card tricks.

The gathering is cheerily philosophical about the rain. We hear from rangers and local observatory

staff about the challenges of running a dark sky tourism business in this corner of Scotland where you can guarantee the dark but not the stars. And we're all uplifted by some exquisite astrophotography of jewelled skies streaked with the Milky Way, of trees silhouetted against star-studded deep blue, and of green and red celestial spotlights from the aurora borealis. The photographers have the skills and the equipment to snatch these moments and save them to treasure and to share. But we have them too, they remind us, in our own mindscape. People remember, the photographers say; they retain vivid experiences of pristine skies from childhood and throughout their life – the way we remember really significant events.

On the second day the participants' patience with the weather is rewarded by the appearance of the sun, and the lawns begin to dry under a big blue sky. By evening, sweet autumn light is flooding the trees with gold and the schedule is back on track with the promise of a bat walk in the woods as darkness falls, then a guided gaze at the celebrated starry sky.

It was my first foray into the insightful, international uplift of dark-sky gatherings. I've been hungry for more ever since and I've kept going whenever I can, whether online or in person. These events are inherently multi-disciplinary – no one department or specialism alone can answer the questions or inform the way forward. Like the sky

itself, light and darkness touch on everything. We need astronomers to tell us about the night sky and what we are losing, we need physicists and photonics experts to understand light and explain the different forms. We need neuroscientists, ophthalmologists and psychologists to examine the impact on human health and wellbeing. We need ecologists and biologists to study the effects on diverse species, habitats and natural systems. We need lighting manufacturers and designers to create more benign light and use it wisely. We need tourism guides to share the darkness and show people the wonder of the stars. We need poets and artists and writers and photographers to articulate that wonder.

Taking part in these gatherings has helped me hold on to a positive perspective through my grief for the loss of the night. While the reach and rapid increase in light pollution is sobering and shocking, the reach of resistance to it is inspiring. And it's also growing at an astronomical rate on all levels, in terms of the range of disciplines involved, the geographic spread of people and projects, and the sheer extent of new research.

Just a few decades ago, light pollution was a small and niche area of academic study, mostly the province of astronomers who were alarmed at the loss of the dark night sky. Now scientists talk of a 'waterfall' or 'explosion' of interest in the subject,

building on every level and in many disciplines. New insights come thick and fast, whether on methods of measuring light, the impact on plants, animals and habitats, or the toll on human health. Dark sky researchers created the Artificial Light at Night (ALAN) Research Literature Database to contain and share this growing dossier of evidence. It has also grown exponentially, with over 400 new papers added each year. It's free and open to all, you can search by scientist or subject (tree, seabird, sleep…) and I often do. It forms more than 4,000 pieces of a jigsaw puzzle and you only need to put a few pieces together to start seeing the bigger picture: ALAN is disrupting everything, and we need an international effort to restore the dark.

Every two years, the global Artificial Light at Night (ALAN) conference gathers experts together to tell their stories and share their discoveries. Lockdown brought it online and also opened it up to all. My understanding grows incrementally through these conferences over the years, gradually deepening my grasp of complex issues. I've learnt about the challenges of monitoring light pollution: so much depends on what, how and even when you measure. The sky gets darker through the night, so measuring a city's light pollution at 11pm or 2am will give different results. Moreover, the satellites that have been used to measure light pollution were

'blind' to certain wavelengths of blue light, meaning we have underestimated the extent to which the transition to blue-rich LED streetlights has made light pollution worse. What is 'eco' depends on what you're trying to achieve, and what you measure – whether the materials, production, the energy or the overall environmental impact.

I've also learnt about the inadequacies of legal protection for the night sky itself and for the species that need the night. Laws that protect wild birds, for example, don't protect them from the impact of artificial light at night. While ALAN has been proven to throw migratory birds off course, mess with the timing of birdsong and lower their resilience to disease, to invoke legal action it has to be proven to kill them directly.

Yet we've also heard hopeful stories of legal advances. Slovenia, for example, has had stringent light pollution laws since 2007, regulating outdoor lighting such as public buildings and sports grounds as well as protecting places where endangered species are nesting. Italy made progress with greater protection after amateur astronomers collected 25,000 signatures to propel their proposals into legislation. The government of Chile recognises light as pollution on a par with other forms of pollution like air and water. Those of us in more backward countries can see glimpses of a better way forward,

and we can speak directly to those involved, meeting in online chat rooms between sessions. From a small terraced house in Cambridge, I talk to a Spanish physicist using a high-altitude hot air balloon to measure light pollution, then a biologist heading out to study glow worms in the Finnish taiga. My view of the bigger picture grows with each conference and every conversation.

DarkSky International certifies the dark sky places throughout the world and coordinates a growing international team of campaigners and activists. Its annual online global gathering 'Under One Sky' takes place over 24 hours in chunks across different time zones. Again, there is a wealth of scientific knowledge and experience here, from astronomy to zoology, with neuroscience and psychology along the way. The learning is exhilarating, and always leaves me bombarding people I meet with 'did-you-knows' for weeks afterwards. Did you know that light-sensing proteins of animals are called opsins and they've been found not just in eyes but body fat and hair follicles? That sky glow from Las Vegas can be seen 150 miles away? That one island in the Azores switched all the lights off when the young seabirds were taking their first flight?

The conference's very title, 'Under One Sky', highlights the sense of the night sky as a shared experience, and also as a shared ancestor. There

is also a place here for deeper human discussion. Wider issues of society and gender, indigenous beliefs and of the depth of feeling and emotion around dark sky experiences are all addressed. As a Chilean architect summarised, "beyond science and tourism, it's something related to our soul".

I live in a strange time zone myself through these conference days, dipping in and out of events in Asia, Australasia and the Americas. I've stayed up late deep in conversation in breakout rooms, raising a glass of whisky to a cheery Australian government researcher who's proud of their efforts to protect sea turtles, engaged in serious discussion with a guy from the Egyptian Space Programme, and commiserated with a woman in Mexico who gets migraines from the new LED streetlights in her neighbourhood. I've set my alarm for 3am and wandered through in my pyjamas as a workshop on astrotourism in Malaysia begins, then it's up in the morning for a talk on lighting policy in the US.

Best of all, of course, is to meet people for real. In 2022, after a string of lockdowns, a posse of dark sky people from around the world gathered at the University of Oxford to pool insights on dark skies and society and strengthen our shared commitment.

We heard from a tourism researcher in Namibia speak about her work combining indigenous knowledge and astrotourism; an American academic

explored bioluminescence as a light source; and re-wilders from the Netherlands led a session outdoors on sharing stories while whittling with knives. A lighting designer described working for a Saudi Prince who wanted to minimise light pollution at a Red Sea resort, and an academic outlined the dubious and sometimes random routes by which science informs government policy.

I was in my element again, enhanced by the post-lockdown thrill of real-life interaction. Many people I'd been following on social media, or whose work I'd been reading online, were right there in person to chat with over breakfast. One night we dined in the grandeur of the Oxford University's dining halls and I found myself discussing lighting policy with an astronomer from Liverpool and an ecologist from Germany. On the last day I went out for an Indian meal with a French philosopher and a Dutch black hole hunter, and followed what I could of the conversation.

As so often at these events, the most important insights come from the chats over coffee and in between sessions. These are the times that people share their own stories, of what set them out on the path that led them to this gathering. That's when I realised that so many of the participants had come to this work through a transformative moment or experience of sudden awareness.

Among them was Hugh, an astrophysicist studying for a PhD on new ways of calibrating gamma ray telescopes. He told me how he'd decided to go to university in his late 20s, after working for some years in engineering. He hadn't yet picked which technical subject to study, first he wanted to do the 'student thing' and go backpacking in South America. And so he found himself camping on top of a mountain in Peru, on a trek to Machu Pichu. "I got up in the night to pee and suddenly the entire universe was above me!" He was 4km above sea level, tens of miles away from human settlements and hundreds of miles from a big city, and there were crystal clear skies. Hugh described the sensation of stepping out of the tent and first being in pitch black. Then he saw the stars, then more stars, then even more stars and became aware of how they were clustering in a big bright band across the sky – the Milky Way. From the southern hemisphere, he was looking right into the centre of it, directly above him. He could see detail, even colour, and he could make out the structure and the lighter patches like fuzzy webs running through it. Awe is the only word for it, he said. It was a glimpse behind a veil and a revelation of how much is beyond that we normally can't see anymore. He determined there and then that whatever he did next with his degree and life, it had to be about protecting the night sky.

The experience also sparked a deep curiosity about what might be up there and what we need to better see it. This led to an interest in telescopes and other instruments to enable closer exploration. Back home, browsing university prospectuses and visiting open days, it seemed the physics departments always displayed pictures of the Milky Way. This resonated with his vivid memories and curiosity, and led him to choose physics and then to focus on astrophysics.

Later, he was able to take his partner to Namibia, where his specialised research telescope is based, and share her version of a similar revelation. "You don't get to see everything right away," he explains, as it takes time for your eyes to adjust and then more stars appear. "You think you're seeing more stars than you've ever seen before, then twenty seconds later you're saying, "*this* is the most I've ever seen," and then again…!" The dry climate in Namibia is ideal for astronomy and the skies are so dark that they were seeing shooting stars about every fifteen minutes. Some years – and an astronomy degree – on from his seminal experience in Peru, Hugh was now looking out at a familiar landscape. He knew what he was seeing and could name constellations and differentiate between planets, pointing out two dwarf galaxies which orbit the Milky Way and could be seen with the naked eye.

Now Hugh is increasingly drawn to outreach and science communication, as well as campaigning for dark sky policy. He hopes to be able to give others the opportunity to 'find their own version of this experience' – both the wonder of the night sky and the transition from a functional job to an inspired path.

During one tea break in Oxford, lighting designer Paul described his 'Sark epiphany'. At the time, he was working on large lighting projects in the Middle East, with clients wanting their buildings lit brighter than anything else around. He thought nothing of it back then; he was just working away on how to ensure these prestigious buildings were seen from many miles away. Then his wife booked a trip to the Channel Islands as a birthday present. Taking the boat from Guernsey to the small island of Sark was like going back in time. With no motorised traffic, they were picked up from the harbour by horse and cart. He knew nothing about the island's dark sky status but was intrigued by the theme apparent on the small high street: there was dark sky jewellery at Sark Silver, dark sky chocolates in the next shop. What was it all about? The shop keeper explained with pride that Sark was the world's first designated dark sky island, and that extreme care was taken with outdoor lighting. He recommended going out to experience the stars for themselves, as clear skies were predicted that night.

Hope, in the Form of Dark Sky Stories

So after dinner Paul and his wife took their drinks to the sun loungers outside the hotel, chatting as the light faded. First the familiar constellations appeared and then all of a sudden – or so it seemed – it was completely dark and the sky was so full of stars that it filled in all the gaps and the constellations disappeared. The stars felt incredibly close, as if they were inches away from his face, and there were so, so many, with the Milky Way spread like a band of smoke across the sky. 'Awesome' is an over-used word, he says, but Paul had an experience of true awe looking out at the edge of our galaxy and thinking about himself as miniscule speck of dust in that immensity.

He was startled to find himself in tears. His father had passed away suddenly that year, and in the presence of this vastness he felt a release of grief and emotion. Something about the sight of the heavens made him contemplate life and death: is there anything else? A God? A purpose? He turned to his wife and asked, "What am I doing, with all these jobs in the Middle East, lighting the sky and losing all this?" He wondered what are we all doing, so full of our own self-importance and busy living our lives without looking at the implications of our actions.

The sky that night changed him. He realised there and then that he needed to start doing a bit more for our tiny planet in this enormous universe.

Ever since, he has dedicated his time to dark sky conservation and policy, as well as running educational events for inner city schoolchildren to experience starry skies. The next present from his wife was a telescope.

The conference was organised by astrophysicist Hannah Dalgleish while a post-doctoral researcher at the University of Oxford. She said that her desire to study astrophysics stemmed from holidays as a child in a remote part of the Scottish Borders. She remembers feeling strangely safe and comfortable in the woods there in the dark, and she felt it made sense to learn more about what we know least about – "such as what 97% of the universe is made of!"

Hannah's first vivid memory of observing the heavens was on a youth group trip to Poland as a 17-year-old, which was also her first time hiking. They settled high in the mountains for the night and when some went off for a stroll a little way from the camp, Hannah joined them. They were talking until they lay on the grass and looked up, becoming quiet. Hannah remembers the elation that came with every falling meteor, and also the significance of it being a shared experience with newfound friends. From then on, she sought out such opportunities, travelling with the International Astronomical Youth Camp and visiting the Arctic, which she describes as a time of great beauty and emotion:

"Upon seeing the aurora borealis, or once, a great fireball of tremendous light, which slowly disintegrated across the sky, I felt a guttural, ancestral response: to yell, gasp, and cry in awe. No matter the differences between us – age, ethnicity, faith, nationality – the night sky is a place under which we rediscover our shared heritage and find a unity of being."

Time and again it seems a sense of connection to the universe leads to a deeper connection to yourself and to others. There's nothing new in this of course. People have been experiencing these feelings since ancient times. Yet this particular mix of people and backgrounds gave me a powerful contemporary reminder of this essential human experience. The stories give me hope, and direction, as I realise the transformation that these individuals have experienced is the transformation that we need undergo as a society. A jolt of realisation, a dose of awe and a rush of wonder are the ingredients needed to create real change so that we value and treasure the night sky.

Experiencing Dark Skies and Enjoying the Dark

1) Take your time

First things first, find as dark a place as possible, switch off the lights and keep them off. If there is any automatic outdoor lighting, tape over the sensor. Darkness can be disconcerting at first, so breathe and slow the impulse to grab for the nearest light or reach for the torch on your phone. It takes time for our eyes to adjust to darkness, at least 20 minutes to gain the night vision required for best seeing the sky. If you switch a bright, white light on, you'll need to begin again with another 20 minutes wait. Night vision will come, trust it and wait patiently, observing and enjoying the changes around you. If you need a torch, bring a red one (a rear bike light will do) as red light doesn't affect dark-adapted vision so much.

2) Share the darkness

There has been a resurgence of popular interest in astronomy, as well as appreciation of dark skies. Maybe it goes together with wild swimming and bird watching in a widespread thirst for a greater connection to our environment. Sky-gazing is a wonderful shared experience, helping to build community

and connections, as well as feeling safer together when out in the dark. Bring hot drinks and warm clothes, as it can be surprisingly cold at night, even in summer, when you're staying still and watching. Get together with friends and pool your knowledge and observations, or check out a local astronomy group or observatory. Enthusiasts are always happy to share their expertise. Optical equipment lets more light in and so enables you to see so much more. Simple binoculars will enhance your vision and specialist telescopes offer an exhilarating reach.

3) Look up, wherever you are

You don't have to escape the city to enjoy the night sky. Yes, for the ultimate stargazing experience it's important to get away from the 'smog' of light pollution, but some of the brightest stars are determined enough to shine even in our cities, just as planets can be spotted and the phases of the moon can still be observed and enjoyed. You can still feel that sense of wonder and connection to the heavens. Most cities have darker areas such as parks, gardens and wooded areas, and many have observatories open to the public and/or astronomy groups with telescopes and guidance to enhance the view and experience. Sometimes what you can see in the city is even more enthralling because of its context. When watching urban wildlife, there's a

particular thrill of a hunting peregrine juxtaposed with city buildings. City sky-gazing also gives us a surreal perspective lurch; there's you on Earth in the middle of a modern city amidst shops and bill-boards, with trams and buses hurtling by, and way up there is another planet – maybe Jupiter – in the city sky, just a few hundred million miles away.

4) Wildlife beyond watching

First, watch with your eyes. Dusk is an important time for the natural world and there's a shift change as daylight fades. Maybe a city fox will slip down a side street, bats will come flickering over a garden, or an otter will slide into a river. Stay outdoors without artificial light and allow night to come slowly. The texture of darkness will thickens and change throughout the night. First your night vision will improve, then, as light lowers to a level where eye-sight falters, the other senses will kick in and become dominant. Listen. What can you hear? Are there insects? Owls calling or screeching? Maybe a deer roaring or a fox screaming? Perhaps frogs croaking or a hedgehog huffing? It's a richer experience of being outdoors and being alive to fully appreciate the sounds, textures and scents of the night. Feel the landscape differently, become aware of the rustle of trees, the sounds of running water, the fish jumping in a river or waves on the beach.

5) Lie down to look up

There's often a best way to view things that goes beyond simply 'looking' to a deeper experience of connection. The right way to view a giant redwood tree, for example, is not to face it and crane your neck peering up into its branches, but to lean back against it. Rest your head on the spongy bark, lean into it and let its softness hold you as you let your gaze follow the magnificent trunk up and up and up... To see the stars, or anything else going on in the sky, lie down to look up. This leads to a far more immersive experience – and it saves a lot of neck ache. A simple reclining chair or sun lounger and a cosy blanket, can be the best 'equipment' needed for enjoying the night sky. If you're out and about, take a camping mat with a sleeping bag or blanket.

6) Join the dots

It adds another dimension to the experience of night to learn about the stars, planets and celestial objects, especially those that you can see with the naked eye. Hand-held star charts, planispheres and star-gazing books are great for navigating the night sky. There are also a range of mobile phone apps that offer real-time information and can identify whatever is above you; just be sure to have the phone on a dark (or red) setting, as the white light from display screens can affect night vision.

Start with a familiar constellation and use this as a reference, moving out from there, 'star-hopping' across the sky. For example, the Saucepan or Plough 'points' to Polaris, the North Star.

Yet knowing the names of heavenly bodies isn't everything, just as you can appreciate plants and wildlife without knowing their names. Sometimes just waving a mobile phone and instantly getting the name from an app can diminish the experience, because it happens so fast and you look less attentively. Just as you'd have to really study a wildflower to get to its name by working through keys in a field guide, the apps work so fast you can simply clock it and move on. Likewise with the sky.

The myths and legends associated with the constellations connect us to the human story in different times and places. Learn about these is a rich experience, but at the same time it's helpful to remember that the names we give the constellations are just descriptions given by humans of a certain culture and point in history. The name is what we have called that pattern, not what it actually *is*. Space is way, way bigger than that. You can also just regard the magnificent whole, seeing infinite patterns, abstracts and options as to how to join the dots. What shapes can you see? Give them names and embroider them with stories. It's not astronomy as we know it, but it's dreamy,

contemplative and fun. Be open to the enormity of a sky full of possibilities.

7) Tune in to the moon

The moon and stars vie for our attention. Light from a full or nearly full moon floods the sky and washes out the light from all but the brightest stars. So, for the best star-gazing with maximum stars, choose a night before, during or just after the new moon, the darkest period in the lunar cycle when the moon can't be seen. A dark, cloudless night around the new moon is also the best time to view the Milky Way and the planets.

Keeping note of the lunar cycle is of course also important for enjoying the moon itself (or herself). The first and last quarters are an ideal time to see the moon's surface, with its craters and mountains in sharp relief along the edge of the line between light and dark. Binoculars will reveal more details of the dark grey 'seas' of cooled lava. Full moon isn't the best time for observing the moon's surface, but it's ideal for enjoying a night time walk, and 'moon bathing' in its silvery light.

8) Feel the seasons

Being attentive to the night sky is another way to tune into the seasons. As the Earth travels around the sun, the stars appear in different positions

and so some can only be seen at certain times of year. Each season has its own skyscape, as well as the changing quality, length and colour of dusks and dawns. Just as some people note the blooming of particular wildflowers, or the arrival of migratory birds, tracking the appearance of seasonal constellations can give a profound awareness of the year – and the planet – turning. This sky calendar was once how people marked time. Summer nights are lovely for being and sleeping outdoors. In winter, as the days shorten, there is more opportunity to enjoy the darkness, and star-gazing comes into its own. Wrap up warm in a cocoon of a sleeping bag on a clear night and feast your eyes on the beauty of natural lights filling the sky.

9) Defend the darkness

Artificial Light At Night (ALAN) is growing at an exponential rate and darkness is under threat throughout most of the world. If any or all of what I've written about in this small book matters to you too, please consider joining the local and international efforts to defend the darkness. This is a political issue at every level and we need to ensure planning regulations and legislation work to protect our dark skies from excess light. ALAN is a thief and is stealing the most beautiful treasure that belongs to us all. We need to fight for the night,

campaigning and raising awareness of what is happening. To sustain and inspire this campaigning we also need a major shift in our attitudes to light and darkness. We need to be enchanted by the dark sky and to show and share our appreciation and sheer enjoyment of real and natural night.

10) Further Resources

DarkSky International:
https://darksky.org

In the UK: www.gostargazing.co.uk

In Ireland: https://www.darksky.ie

The ALAN database:
https://www.zotero.org/groups/2913367/alan_db/library

Notes and References

Chapter 2

1 John Barentine, *The Lost Constellations: A History of Obsolete, Extinct, or Forgotten Star Lore*, Springer Praxis Books, 2016

2 Barry Hetherington, *A Chronicle of Pre-Telescopic Astronomy*, John Wiley & Sons, 1996

3 I was flicking through: Hetherington, Barry, A Chronicle of Pre-Telescopic Astronomy, John Wiley & Sons, 1996

A section of this chapter was first published as 'Lying Down to Look Up' by Open Book Unbound Writing, February 2024,: openbookreading.com/wp-content/uploads/2023/10/OBU-Unbound-Writing-Anna-Levin-Mar-24.pdf

Chapter 6

4 Josie Long, 'The Little Nuneen', Radio 4, Broadcast 11 July 2019

5 Terry Walsh, 'Sappho and the Moon', *The Classical Anthology*, 30 March 2013, Accessed online at classical-anthology.theclassicslibrarycom/2013/03/30/sappho-and-the-moon/ (accessed 30 August 2024)

6 Li Bai (701–762), 'Thoughts in the silent night'. Accessed online at www.confuciusinstitute.ac.uk/the-story-be-hind-mid-autumn-festival/(accessed 30 August 2024)

7 Li He (791-817), 'Up in Heaven'. Accessed online at www.cjvlang.com/Pfloyd/liho1.html (accessed 30 August 2024)

8 Walt Whitman (1819–1892), 'Miracles'. Accessed online at poets.org/poem/miracles (accessed 30 August 2024)

9 Walt Whitman (1819–1892, 'On the Beach at Night Alone'. Accessed online at poetryfoundation.org/poems/48856/on-the-beach-at-night-alone (accessed 30 August 2024)

10 Emily Dickinson (1830 –1886) 'I saw no Way – the Heavens were stitched'. Accessed online at allpoetry.com/I-saw-no-WayThe-Heavens-were-stitched (accessed 30 August 2024)

11 'Stars Over Cloughanover' (L. Moran / D. Carton). The Saw Doctors' recording of the song is included in the band's compilation album 'To Win Just Once – The Best Of The Saw Doctors'.

12 Paula Jennings, 'Spring Again'. Published in *Northwords Now* and accessed online at www.scottishpoetrylibrary.org.uk/poem/spring-again/ (accessed 30 August 2024)

13 Claire Askew, 'Bad Moon', accessed online at www.scottishpoetrylibrary.org.uk/poem/bad-moon/ (accessed 30 August 2024)

14 Walt Whitman (1819 – 1892) 'The Nighttime Sky', accessed online at inthewordsofwaltwhitman.com/nature-2/in-the-air/the-nighttime-sky/ (accessed 30 August 2024)

Chapter 8

15 Peter Hill, *Stargazing: Memoirs of a Young Lighthouse Keeper*, Canongate, Edinburgh, 2003

16 Erich Hoyt, *Creatures of the Deep*, 2nd Edition, Firefly Books, Ontario, 2014

Acknowledgements

My thanks to all at Saraband: especially Sara Hunt for again recognising that I had a story worth telling; to editor Rosie Hilton; and proof-reader Emma Rushfirth.

Thank you to the following people for granting permission to reproduce copyrighted quotations in the text:

Claire Askew, for permission to quote the lines from her poem 'Bad Moon';

Anne Jennings, for her kind permission to reproduce lines from 'Spring Again', by Paula Jennings;

Leo Moran and David Carton for permission to reproduce lines from the song 'Stars Over Cloughanover' (L. Moran / D. Carton), included in The Saw Doctors compilation album '*To Win Just Once*'—*The Best Of The Saw Doctors*.

Grateful thanks to all who checked chapters, offered expertise and cheered me on, especially: John Barentine, Erich Hoyt, Steve Leach, Eleanor Levin, John Lincoln, Georgia Macmillan, Simon Nicholas, Sam Robinson and Padraig Stevens.

And to all involved in the charity LightAware.
 (www.lightaware.org)

Thank you Hannah Dalgleish, Paul Gregory and Hugh Spackman for the honour of sharing your dark sky stories.

Thank you to my unions: The Society of Authors for the Authors' Foundation Grant for work in progress, which helped me through the writing of this book. The NUJ for my mentor Jean Rafferty, who lifted me when I was low and kicked my butt into gear when I needed it most.

Special thanks to Joon for the precious gift of space to write.

And to Rob, for everything, always.

Also in the
IN THE MOMENT Collection

Portable, accessible books exploring the role of both mind and body in movement, purpose and reflection, finding ways of being fully present in our activities and environment.

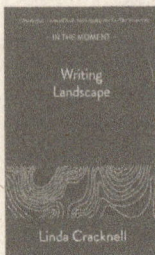

Writing Landscape: In this varied collection of essays, Linda Cracknell explores her inspirations, in nature and from other artists and their work, shows how her writing flows from her engagement with place, and offers prompts for the reader.

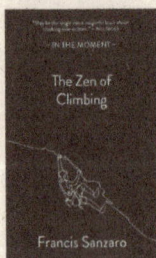

Philosopher–climber Francis Sanzaro shows that climbing is a sport of perception, a matter of mind as much as body, and in *The Zen of Climbing* he offers pathways into attaining the mindset required for effective, alert, successful practice.

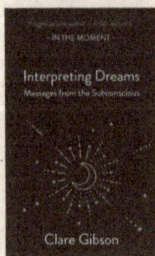

Interpreting Dreams is both an invitation to pay more attention to our dreams and a toolkit for unlocking their hidden meanings. By bringing our awareness to the time we spend dreaming, we can become more present and fulfilled in daily life.

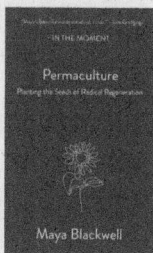

Permaculture: Planting the Seeds of Radical Regeneration. Practitioner and poet Maya Blackwell writes with expertise and personal experience of the transformative power of permaculture for both people and the planet. An essential resource in tackling the climate crisis.

Poet and essayist Kenneth Steven takes us on a series of meditative quests in search of his "atoms of delight"—treasures, both natural and spiritual—through some of Scotland's most beautiful landscapes. An evocative book that will inspire you to explore mindfully.

Scotland's foremost nature writer, Jim Crumley, draws us into his magical world with insights from his decades of experience in observing wild animals and birds. He shows how we can learn to watch wildlife well, and what this can mean for our ability to care for it, and care for ourselves.

Taking time for nature poetry is an act of reverence for the natural world, and a path to understanding our part in it. Full of surprises, this anthology shows the breadth of writing on the natural world, and challenges homogenous ideas of what a nature poet can look like.

Anna Levin is a writer, wildlife-watcher and star-gazer with a special interest in the natural world and people's connection with it. She makes complex scientific subjects accessible to a general readership. A former section editor with *BBC Wildlife*, Anna writes and edits for a wide variety of publications and environmental organisations. Her book *Incandescent: We Need to Talk about Light,* a deep dive into our relationship with artificial light, was published by Saraband in 2019. She often works in collaboration with photographers and is a caption writer for the Natural History Museum's Wildlife Photographer of the Year competition. She runs writing workshops based on nature and life writing and in creative writing through the Scottish charity Open Book. Anna is an active volunteer for the charity LightAware, which seeks to raise awareness of the impact of artificial light on human health and well-being.